WILLIAM
HENRY
FOX
TALBOT

Adapted from the cover design by Owen Jones (1809-1874) of William Henry Fox Talbot's *The Pencil of Nature*, published privately in six parts by William Henry Fox Talbot, June 1844 to April 1846, printed by Longman, Brown, Green, & Longmans, London.

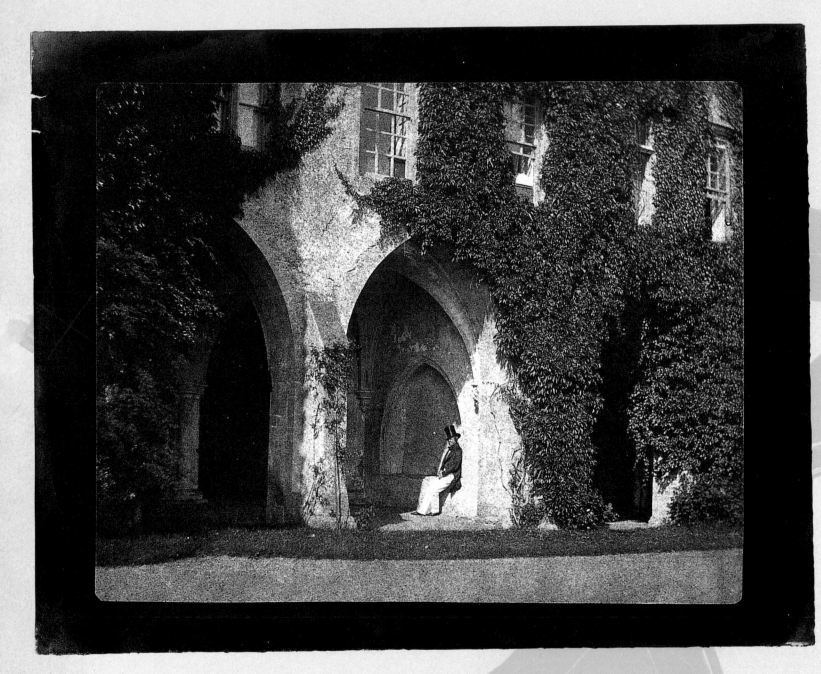

Calvert Jones in Cloisters, Lacock Abbey,
salt paper print, ca. 1843
$9^{23}/_{32}$ x $7^{23}/_{32}$" (24.7 x 19.6 cm.)

SPECIMENS AND MARVELS

WILLIAM HENRY FOX TALBOT

AND THE INVENTION OF PHOTOGRAPHY

APERTURE

NATIONAL MUSEUM OF PHOTOGRAPHY,
FILM & TELEVISION, BRADFORD

PREFACE
ANTHONY BURNETT-BROWN

The stable court, Lacock Abbey, calotype negative, ca. 1841
3¹⁵⁄₁₆ x 4½" (9.9 x 11.4 cm.)

William Henry Fox Talbot was born in 1800, and it is fitting that the two hundredth anniversary of that event should be celebrated. While remembering him as a scientist, it is a pity that we do not know more about him as a man. My great-aunt Matilda Talbot, who was his granddaughter, could just recall meeting him when she was a young girl, and described him as a kind and friendly old gentleman with a farseeing look in his eyes; but by all accounts he was a rather withdrawn personality, though he had a wide circle of friends in the scientific field. His mother and sisters lived a very active social life, but despite this—or perhaps because of it—he seemed to have had no great inclination to follow suit. He performed his duties as a country landowner and MP, but devoted much of his time to his scientific studies. He had something of a reputation for absentmindedness. It was his custom to dilute his after-dinner port with water; on one occasion it seemed to be getting stronger rather than weaker, and he found that instead of water he had been adding gin.

His name was quite well-known in his lifetime, particularly in scientific circles: of course for photography, but also for his achievements in botany, chemistry, optics, and cuneiform inscriptions—a field that may seem to sit rather oddly with his other accomplishments, but he had a lifelong interest in language in all its various forms. His work in mathematics is today largely neglected, but the subject was probably his most enduring interest; he was made a Fellow of the Royal Society, largely for his mathematical work. After his death, in 1877, his reputation faded somewhat (which would have disappointed his mother greatly, since she was always concerned that he should have the fame he deserved), and it was not until the 1930s that he began to be better known. This was largely the result of hard work by my great-aunt, assisted by some of the leading photographic historians of the day. It is a tribute to the success of their endeavors that the celebrations of his work in the year 2000 have been so well received. He might, if he could have seen them, have been rather bewildered by some of the interpretations put on his images, but he would certainly have been fascinated by modern processes such as digital photography and would have been keen to participate in exploring the technology involved.

SPECIMENS AND MARVELS
THE WORK OF WILLIAM HENRY FOX TALBOT
RUSSELL ROBERTS

Our fine arts were developed, their types and uses were established, in times very different from the present, by men whose power of action upon things was insignificant in comparison with ours. But the amazing growth of our techniques, the adaptability and precision they have attained, the ideas and habits they are creating, make it a certainty that profound changes are impending in the ancient craft of the Beautiful. In all the arts there is a physical component which can no longer be considered or treated as it used to be, which cannot remain unaffected by our modern knowledge and power. For the last twenty years neither matter nor space nor time has been what it was from time immemorial. We must expect great innovations to transform the entire technique of the arts, thereby affecting artistic invention itself and perhaps even bringing about an amazing change in our very notion of art.

—Paul Valéry, "The Conquest of Ubiquity," 1928

In Hannah Arendt's anthology of the work of cultural critic and philosopher Walter Benjamin, the now well-known essay on *The Work of Art in the Age of Mechanical Reproduction* opens with the above quote from Paul Valéry.[1] Valéry describes the way technology transforms our perceptions of things, suggesting what the impact of new technologies might be on the values and beliefs of the time. The quote foregrounds Benjamin's important essay examining the mass experience of art and Capitalist rituals surrounding the authenticity of the art object. Benjamin is receptive to the characteristics and effects of reproductive technologies but tends to concentrate on the technology itself, its long term effects, as a means of challenging established ideological beliefs and cultural values. Conversely, looking at the early experience of a new technology as it first enters the public domain, often carries with it the promises and desires of its makers and provides an equally valuable commentary that speculates on what that impact on cultural values might be. In this respect, Valéry's words also provide a valuable framework from which to turn to one of the most well-documented moments at the beginnings of photography, a period that was accompanied by a sophisticated consciousness of the impact of a new technology and of how it might transform the way that society would see itself and others.

Looking back at the first decade of the medium, we find not only a remarkable project that laid the foundations for the modern negative/positive process, but also a sensibility that anticipated many of the future uses of photography. Talbot's intellectual make up was in some ways typical of the amateur, gentleman scientist of the time. A precocious scholar from an early age, Talbot later entered many learned societies, and contributed over fifty papers to scientific and mathematical journals. In addition to these achievements, his work also included philology, optics, and the translation of ancient languages such as cuneiform scripts and hieroglyphics. His diverse interests played a fundamental part in breathing life into what was initially a fanciful idea, and later determining the versatility of photography. Through his own abilities and with some assistance from his family's social network, Talbot became part of scientific circles that included luminaries such as John Herschel, Michael Faraday, David Brewster, Charles Wheatstone, and Charles Babbage. Correspondence and friendship between these individuals helped to position photography as an important scientific discovery.

In the opening pages to his seminal work *The Pencil of Nature* (1844–46), Talbot mapped out the benefits he believed the new invention of photography would bring to art, science, and commerce. Aware of the modernity of photograph and its radical departure from traditional modes of representation, Talbot introduces the reader to carefully chosen examples of the medium's potential. Published over two years in six fascicles, a total of twenty-four photographic plates appeared accompanied by a short text. An important part of the text is a series of observations on the characteristics and effects of camera vision where time, detail, frame, and perspective are intelligently considered. *The Pencil of Nature* is recognized not only as the first commercially produced book to be illustrated with photographs, it constitutes the first philosophy of photography, a demonstration of its causes, effects, and possibilities.

Specimens and Marvels draws on *The Pencil of Nature* for its points of reference, concentrating on reproduction. It does not look to simply celebrate Talbot as an artist but to evoke something of the different cultural beliefs that infused his research in order to appreciate what kind of "aesthetics" or values that might have been at work. Talbot's experiments took place when modern science in Europe was emerging. However, Talbot's thinking was more a product of the eighteenth century. In this respect, *Specimens and Marvels* considers the early experience of wit-

nessing photography in relation to the marvelous, as an experience that could not easily be contained by modern scientific thought. As Talbot himself noted in his first published account of photography:

"The phenomenon which I have now briefly mentioned appears to me to partake of the character of the marvellous, almost as much as any fact which physical investigation has yet brought to our knowledge."[2]

The marvelous has long been associated with nature's wonders or marvels, a defining feature in the cultural landscape of educational collections and displays that preceded the arrival of photography. Much of the early language used to describe photography resonated with conceptions of natural world derived from infusion of natural philosophy, metaphysics and alchemy. The following section—*Experiments*—introduces aspects of this otherworldliness in relation to some of the images made during the early years.

The Pencil of Nature also portrayed photography as something distinctly new; pictures that underlined its capacity to create order celebrated its realism and authenticity. In time the photograph would come to be seen as both an agent of classification and as an object that needed to be classified. There is a relatively unexplored parallel between the rise of the modern museum and the emergence of photography. Talbot created in *The Pencil of Nature* a kind of museum, an exhibition of photography's potential, a display of the utilitarian uses of photography accompanied by philosophical speculation on its effects. In staged pictures such as *Articles of China*, ca. 1843 (p. 74) and *Scene in a Library*, ca. 1844 (p.74), we are invited to look at these scenarios not just in relation to the photographic rendering of them, but in relation to different modes of display, at once museological, commercial, and domestic. *The Pencil of Nature* is in many ways like the museums that began to collect and use photography—an exercise in classification.

The 1850s saw the entrance of photography into the museum both as an art form, and as a means of documenting and disseminating its collections. The photograph provided a new space for the display of artifacts, fulfilling part of Talbot's vision and the pedagogic function of these institutions. The South Kensington Museum, London, was the first museum to display and acquire examples of Talbot's work. Prints and equipment were shown at several exhibitions until the end of the nineteenth century when the museum separated to form the Victoria and Albert Museum and the Science Museum in London. Amongst the exhibitions in which Talbot figured, were the *Society of Arts at The Adelphi*, London, 1852, and the *S. T. Davenport Collection*, 1869, and the *Special Loans Exhibition* in 1876 at the South Kensington Museum. The purpose of these exhibitions was to educate visitors to the potential of photography in its various applications. Clearly the values that determined the exhibition of Talbot belonged to both the growth of photography as art and as a reproductive technology. However, the bulk of Talbot's archive entered the Science Museum in 1934, in recognition of his contribution as a scientist, and in photographic reproduction as an alternative to printing. Looking back at the division of photography into science and art by the museum, one can see how the fluid boundaries between disciplines that were so vital to Talbot's thinking and cultural milieu were effectively erased.[3]

Over six thousand prints, negatives, and a selection of notebooks, cameras, and correspondence owned by Talbot were kindly donated by his granddaughter, Matilda Talbot. This acquisition was prompted by the then Keeper of Chemistry, Alexander Barclay, who visited Lacock during 1934 to see a rather curious exhibition. Organized by Matilda, the exhibition marked the centenary anniversary of Talbot's first experiments with photography. Using clothes horses, book shelves, and hessian cloth as makeshift display stands, the rooms of Lacock were hung with hundreds of photographs to celebrate the work of one its greatest pioneers. In some ways the display, rudimentary yet instructive, set against the muffled background of Talbot's home, conveys a sense of the marvelous, the extraordinary, and the mildly eccentric. Objects can be seen that figured in some of Talbot's studies, and caught albeit fortuitously—almost as testimony to one of those incidental details that Talbot relished discovering in his own pictures— are the diamond shaped panes of glass of the *Latticed Window* (p. 8). Following this visit, Barclay began the process of acquisition which eventually saw the final part of the donation enter the Science Museum Collections in the late 1930s.

The classification of Talbot and the interpretation of his work has changed considerably since then. One important change was in the actual location of his collection, which moved from the Science Museum during the 1980s to the new National Museum of Photography, Film and Television in Bradford, England. *Specimens and Marvels* builds on the work of the Science Museum/NMPFT curators—David Thomas, John Ward, and Roger Taylor—and those whose have assisted with promoting a wider appreciation of Talbot through the following projects: *From Today Painting is Dead—The Beginnings of Photography*, 1972; *Sun Pictures*, 1977; *Printed Light*, 1986.[4] This extraordinary collection—to which this book is just an introduction—is a unique resource for understanding the beginnings of photography on paper, and provides ways of thinking that are relevant to our evaluation of contemporary photographic practice and new imaging technologies.

EXPERIMENTS

"Surely you deal with the naughty one"

The Villa Melzi, 5th October 1833,
camera lucida drawing: pencil on
paper, ca. 1833
8¹⁹/₃₂ x 5¹⁹/₃₂" (21.8 x 14.2 cm.)

The most transitory of things, a shadow, the proverbial emblem of all that is fleeting and momentary, may be fettered by the spells of our "natural magic," and may be fixed forever in the position which it seemed only destined for a single instant to occupy.

—W. H. F. Talbot, Some Account of the Art of Photogenic Drawing, 1839

I read your circular received this morning giving an account of the Kalotype [sic]. I always felt sure you would perfect your processes till they equalled or surpassed Daguerre's, but this is really magical. Surely you deal with the naughty one.

—J. F. W. Herschel, letter to Talbot, 1841

In the opening pages of *The Pencil of Nature*, Talbot describes the series of events that led to that all-important moment when the idea of photography first occurred to him. The place was Italy, the year 1833. Talbot was traveling with his wife, Constance, and his mother, Lady Elisabeth Feilding. During the trip, while sketching on the shores of Lake Como, he attempted to record various views with the aid of William Hyde Wollaston's camera lucida. After tracing the image projected on paper through the prism of the camera lucida and contemplating the rudi-

Latticed window taken with the camera obscura, photogenic drawing negative, August 1835
Mount: 2²³/₃₂ x 5⁷/₈",
Image: 1¹³/₃₂ x 1³/₃₂"
(Mount: 6.9 x 14.9 cm.,
Image: 3.6 x 2.8 cm.)

mentary sketches before him, Talbot confronted in the uncomplimentary network of pencil lines—"traces on the paper melancholy to behold."[5]

Continuing his account (and still lamenting his inability to draw), Talbot considers in contrast, the images he had seen on the glass screen of the camera obscura the preferred drawing aid of eighteenth-century artists:

> *And this led me to reflect on the inimitable beauty of the pictures of nature's painting which the glass lens of the Camera throws upon the paper in its focus—fairy pictures, creations of a moment and destined as rapidly to fade away.*
>
> *It was during these thoughts that the idea occurred to me . . . how charming it would be if it were possible to cause these natural images to imprint themselves durably and remain fixed upon the paper! And why should it not be possible? I asked myself.*[6]

The idea can be seen, then, to have arisen from both scientific conjecture and, as Talbot himself noted, "Whether it had ever occurred to me before amid floating philosophic visions, I know not. . . ."[7] Arguably, the idea was possibly driven by a sense of failure as a draughtsman, and perhaps of wounded pride or humility arising from that failure in the presence of Talbot's wife and mother. Ineptitude may have been a rare experience for him, accomplished as he was in botany, mathematics, chemistry, etymology, philology, physics, and optics. Making a note of his idea, he returned to England in 1834 and began his experiments "on the art of fixing a shadow."[8]

The causes and effects behind photography had been discussed in principle by a number of earlier European thinkers. In 1669, for example, Athanasius Kircher had published a book containing an illustration of the use of the sun for printing, and in 1725 Johann Heinrich Schulze had observed the light-sensitive properties of silver salts. To these observations must be added the practical experiments of Thomas Wedgwood and Humphry Davy in the 1790s. Talbot referred to the latter partnership in *The Pencil of Nature*, stating that he was unaware of these experiments before

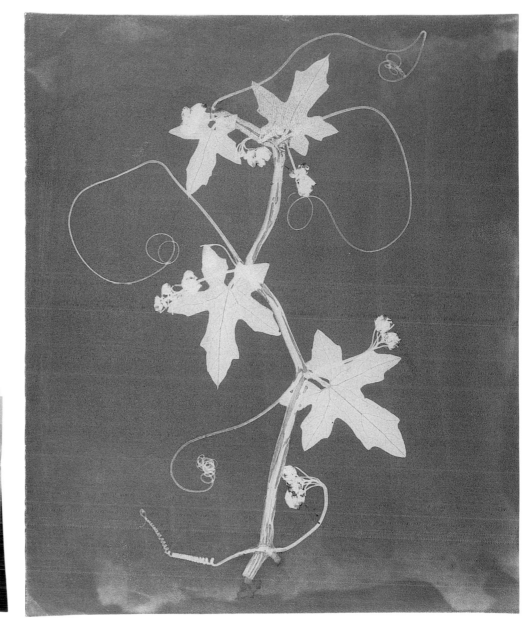

undertaking his own researches. However, there are similarities between his project and theirs in that Wedgwood and Davy apparently reproduced outlines or shadows of objects (including leaves, insect wings, and paintings on glass) on a surface sensitized with silver nitrate. They also proposed the use of a camera obscura.[9]

Phrases such as "fairy pictures," "natural magic," "words of light," the "black art," "magic pictures," and "nature's marvels" were among the early vocabulary used to describe photography.[10] The nineteenth century was a period of great advances in both the arts and the sciences, but Talbot's thinking was also infused with a blend of natural philosophy, Romanticism, and experimental science linked with the latter half of the eighteenth century. The language he used to describe photography resonates with the irrational or supernatural. Despite the emergence of modern scientific thinking, alchemy remained a powerful symbol of chemical change during

this period, even if it was part of an outdated and occult view of the world. The miraculous transformation of substances sought in alchemy evoked ideas of photography as a piece of "natural magic."[11] This idea was to gain strength with Talbot's discovery of the latent image in September 1840—the process by which after a brief exposure a negative image could be chemically developed out of the sensitized paper—an innovation that led Talbot's friend Sir John Herschel to the diabolical suggestion, "Surely you deal with the naughty one." This playful notion of a satanic partnership in the discovery of the negative/positive process reflects Herschel's awareness of how significant this discovery was. The concept of latency had figured in a notebook of Talbot's as early as around 1831, where, using chemical combinations to produce "secret writing," he wrote, "First concealed, at last I appear."

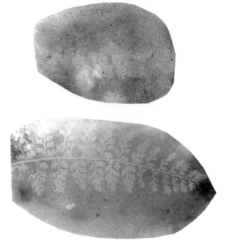

Talbot's surviving images from this initial period of experimentation were produced in three different ways: contact prints of objects, images made using a modified camera obscura (made by a local carpenter and affectionately termed "mousetraps" by Talbot's wife on account of their size and appearance), and the solar microscope. Each method involved a different relationship between the object and the way it is represented and were collectively described as photogenic drawings. Photographs of lace, Lacock Abbey, painted glass, and botanical specimens also supposed a new kind of observer, one who can contain the world and its objects in either miniaturized or enlarged form.

Talbot's work was promoted via the Royal Society, where his experiments and discoveries were described in a paper read to its members on January 31, 1839. This lecture took place over three weeks after the announcement in Paris of another photographic process invented by Louis Jacques Mandé Daguerre. Seeking to claim his position in the origins of photography, Talbot reinforced his written account with a series of small "exhibitions," the first being first in the library of the Royal Institution. In August that year he showed a selection of "specimens" at a Birmingham meeting of the British Association for the Advancement of Science. Categories included "Images obtained by the direct action of light and of the same size with the objects (lace, lithographs, botanical specimens);" reversed images, requiring the action of light to be twice employed (copies of painted glass, and printed pages from books); views taken with the Camera Obscura (Lacock Abbey); "Images made with the Solar Microscope (lace magnified 100 and 400 times)." These images were part of an early complex of images that provided a set of characteristics from which to gauge the potential of photography.

In a letter to Talbot in 1840, his uncle William Fox-Strangways classed photogenic drawings into ten divisions and proposed that "Two or three styles might be brought into one drawing and if well combined would make a better specimen of the art."[12] Talbot's pictures are predominantly hybrid in construction: not only do they concentrate on the reproductive potential of photography, they engage with the subjects of his interests and philosophical investigations on many levels. It is with this in mind that the following sections of this book have been put together.

(Above) *Plant specimen exposed by moonlight*, photogenic drawing negative, April 1841
2⁵/₃₂ x 2¹⁷/₃₂" (5.5 x 6.42 cm.)

(Opposite top left) *Copy of a print, jester and cat*, photogenic drawing negative, ca. 1839
2¹⁵/₁₆ x 3³/₃₂" (7.5 x 7.9 cm.)

(Opposite top right) *Copy of a coat of arms from stained glass*, salt paper print from photogenic drawing negative, ca. 1839
6²⁵/₃₂ x 8 ¾" (17.9 x 22.2 cm.)

(Opposite bottom) *Copy of engraving on glass of a bird of prey*, salt paper print, ca. 1839
6²⁵/₃₂ x 8¾" (17.2 x 9.9 cm.)

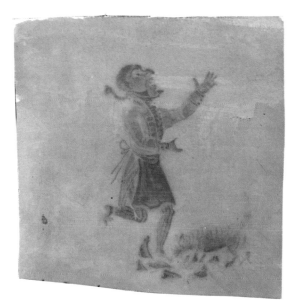

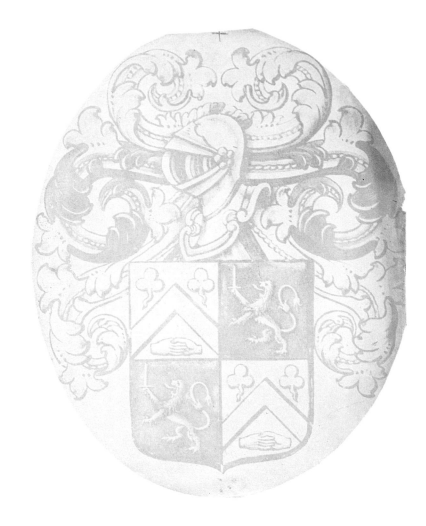

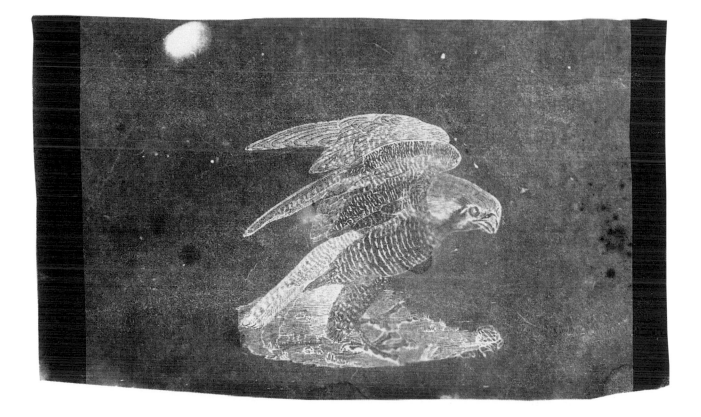

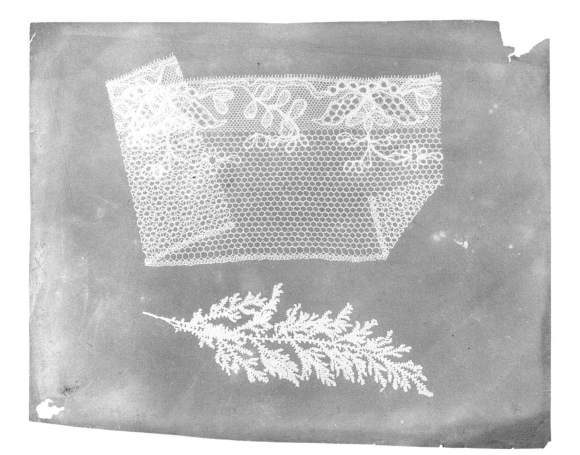

Folded lace and botanical specimen,
photogenic drawing negative,
ca. 1839
$8^{31}/_{32}$ x $7^{3}/_{8}$" (22.8 x 18.7 cm.)

Bust of Napoleon,
salt paper print from a photogenic
drawing negative, ca. 1840
$9^{1}/_{16}$ x $7^{9}/_{32}$" (23 x 18.5 cm.)

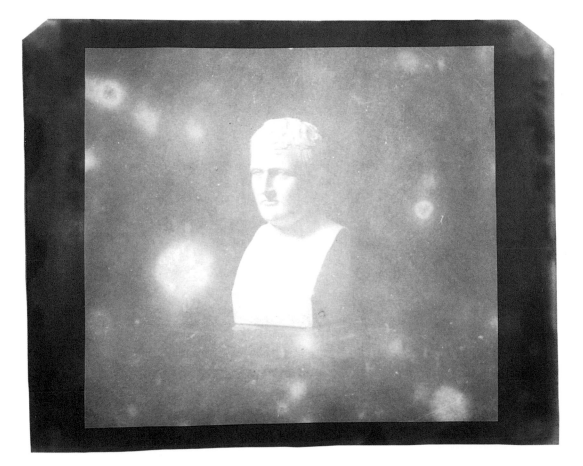

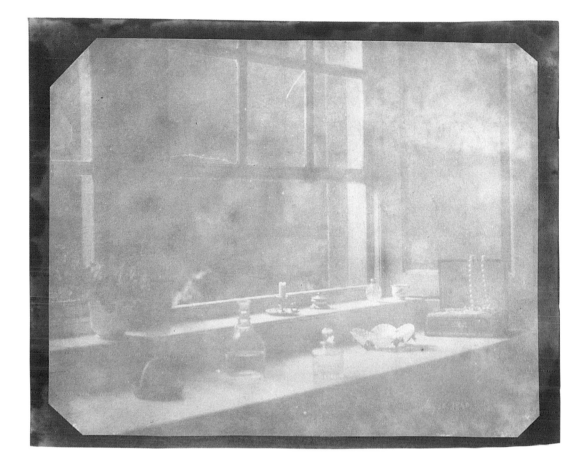

Sunlit objects on a window ledge,
Lacock Abbey,
salt paper print from a photogenic
drawing negative, ca. 1840
8¹⁵/₁₆ x 7¹/₈" (22.7 x 18.1 cm.)

Footman,
salt paper print from a calotype
negative, October 14, 1840
9¹/₁₆ x 7⁵/₃₂" (23 x 18.2 cm.)

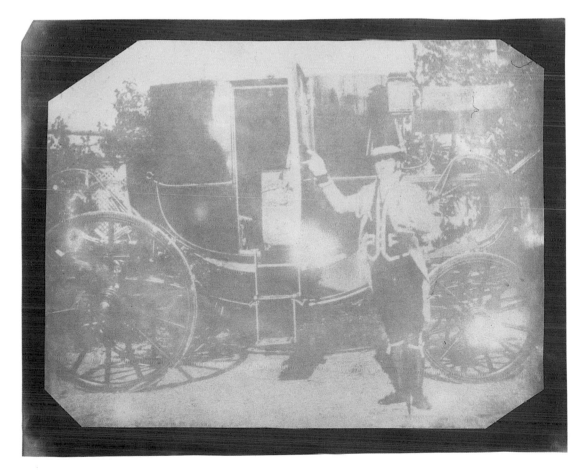

THE ORDER OF NATURE

It is so natural to associate the idea of labour with great complexity and elaborate detail of execution, that one is struck at seeing the thousand florets of an Agrostis depicted with all its capillary branchlets . . . for the object which would take the most skilful artist days or weeks of labour to trace or to copy, is effected by the boundless power of natural chemistry in the space of a few seconds.

> —W. H. F. Talbot, *Some Account of the Art of Photogenic Drawing*, 1839

No human hand has hitherto traced such lines as these drawings display; and what man may hereafter do, now that Dame Nature has become his drawing mistress, it is impossible to predict.

> —Michael Faraday, *Literary Gazette*, 1839

The experience and definition of nature and culture were to be dramatically transformed during the nineteenth century as a result of industrialization. Photography participated in this process of transformation by introducing a document that would bring about new methods of observation and classification.

Talbot's interest in nature was varied. As a young student he compiled an inventory of *Plants Indigenous to Harrow: Flora Harroviensis* (1814–15) and later at Lacock, he cultivated specimens in his herbarium which were then used as subjects for photogenic drawings. Botany figured prominently as an interest throughout the Talbot family, as it did with many of the educated classes, and this made for an obvious subject matter for the early photographic experiments. The intricate patterns and shapes of leaves left shadows of their designs in the fibers of writing paper coated with silver nitrate, and in the words of Talbot "make very pleasing pictures."[16] Nature was tamed by photography but the photograph was understood as an expression of natural laws—as "nature's pencil."[17]

Photogenic drawings of plants resembled earlier forms of "nature printing" where an ink-covered specimen was pressed in contact with the paper to make an image. In Talbot's case, plant specimens were held like pressed flowers in a printing frame in direct contact with the paper, fastened with screws. Commenting on a plate of a leaf in *The Pencil of Nature*, the *Literary Gazette* remarked that it was "nature itself—how valuable for botanical science."[18] Though the book contained only one plate dedicated to this subject, it was evident that the new process would change the study of the natural world. However, the first serious attempt to com-

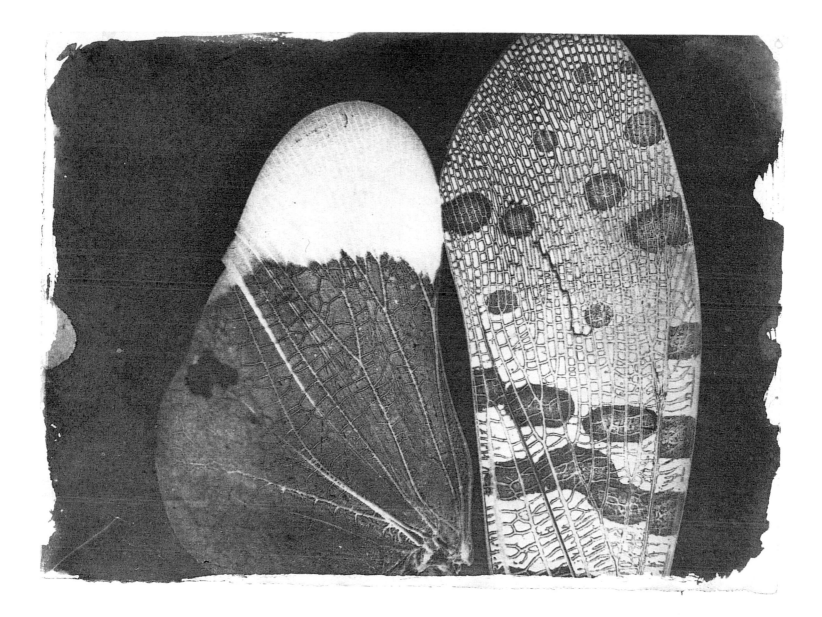

Insect wings,
salt paper print, ca. 1839
$7^{19}/_{32}$ x $7^{13}/_{16}$" (19.3 x 19.9 cm.)

pile a visual inventory of botanical specimens through photography rests not with Talbot, but with the pioneering work of Anna Atkins's limited edition, *British Algae* (1843).

Talbot was the first to apply photography to the microscope in his studies of light transmitted through crystals (ca. 1839), and the cross-sections of plants (ca. 1939), demonstrating that a dimension of nature invisible to the naked eye could now be observed, scrutinized, and accurately reproduced.

Photography's proximity to nature in the nineteenth century was to shift as it became part of its technological expansion. The photograph became the messenger of a different state of consciousness, where the conflict between Romanticism and technological modernity made different claims to the way nature was experienced and understood.

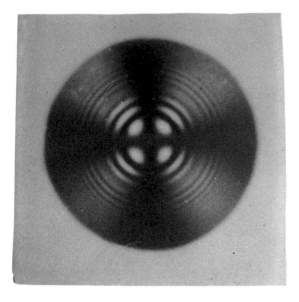

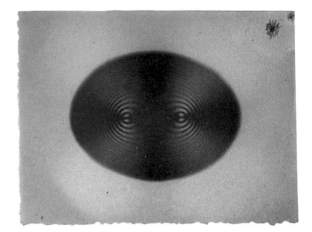

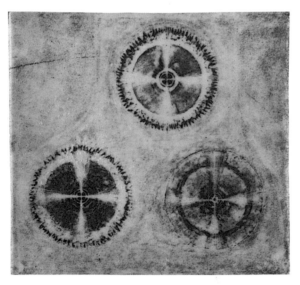

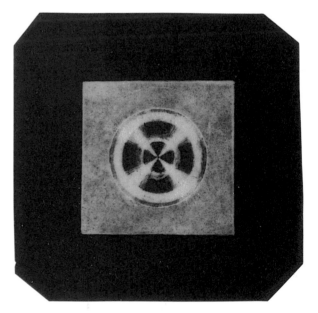

All images from W. H. F. Talbot Collection

(Top left) *Photomicrograph of a crystal—study of polarized light,* albumenised paper print, ca. 1851 2⁷/₁₆ x 2⁷/₁₆" (6.2 x 6.2cm.)

(Bottom left) *Photomicrograph of three crystals—study of polarized light,* calotype negative, ca. 1840 2¹³/₃₂ x 2⁷/₃₂" (6.1 x 5.6 cm.)

(Top right) *Photomicrograph of interference patterns—study of polarized light through crystals,* albumenised paper print, ca. 1851 1²⁵/₃₂ x 2⁵/₁₆"(4.5 cm x 5.9 cm.)

(Bottom right) *Photomicrograph of interference pattern—study of polarized light through crystals,* albumenised paper print, ca. 1851 2⁵/₁₆ x 2⁵/₁₆" (5.9 cm x 5.9 cm.)

Photomicrograph of a feather,
salt paper print, ca. 1841
3¹¹/₃₂" x 3¹⁷/₃₂" (8.5 x 9 cm.)

Two photomicrographs of plant stems,
salt paper print from photogenic
drawing negative, ca. 1839
9¹/₃₂ x 7¹/₂" (22.9 x 19 cm.)

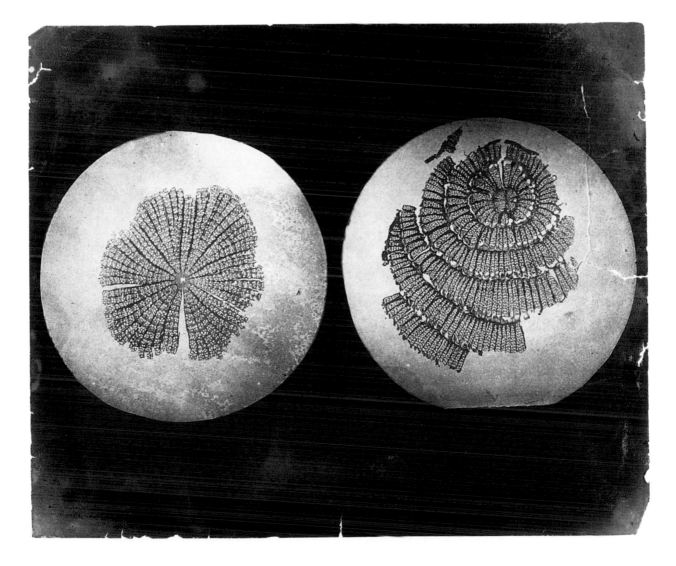

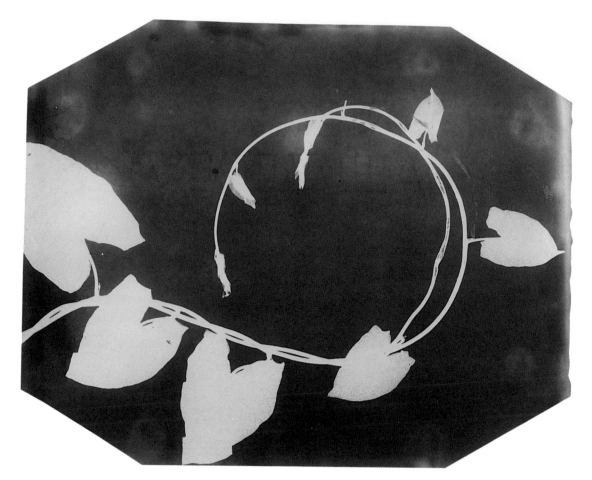

(Left) *Botanical specimen*, photogenic drawing negative, ca. 1839
$8^{29}/_{32}$ x $7^{9}/_{32}$" (22.7 x 18.5 cm.)

(Bottom left) *Single leaf*, salt paper print from a photogenic drawing negative, ca. 1840
$3^{11}/_{32}$ x $3^{23}/_{32}$" (8.5 x 9.4 cm.)

(Bottom right) *Single leaf*, photogenic drawing negative, ca. 1840
$3^{1}/_{2}$ x $3^{3}/_{8}$" (8.9 x 8.6 cm.)

(Opposite) *Botanical specimen*, photogenic drawing negative, ca. 1839
$7^{13}/_{32}$ x $9^{1}/_{16}$" (18.8 x 23 cm.)

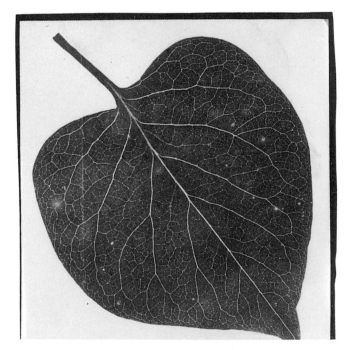

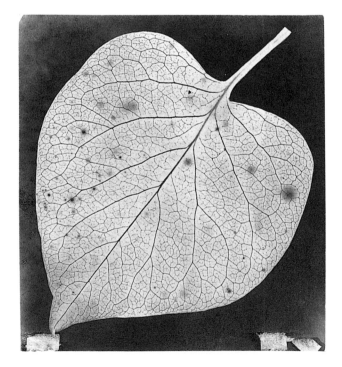

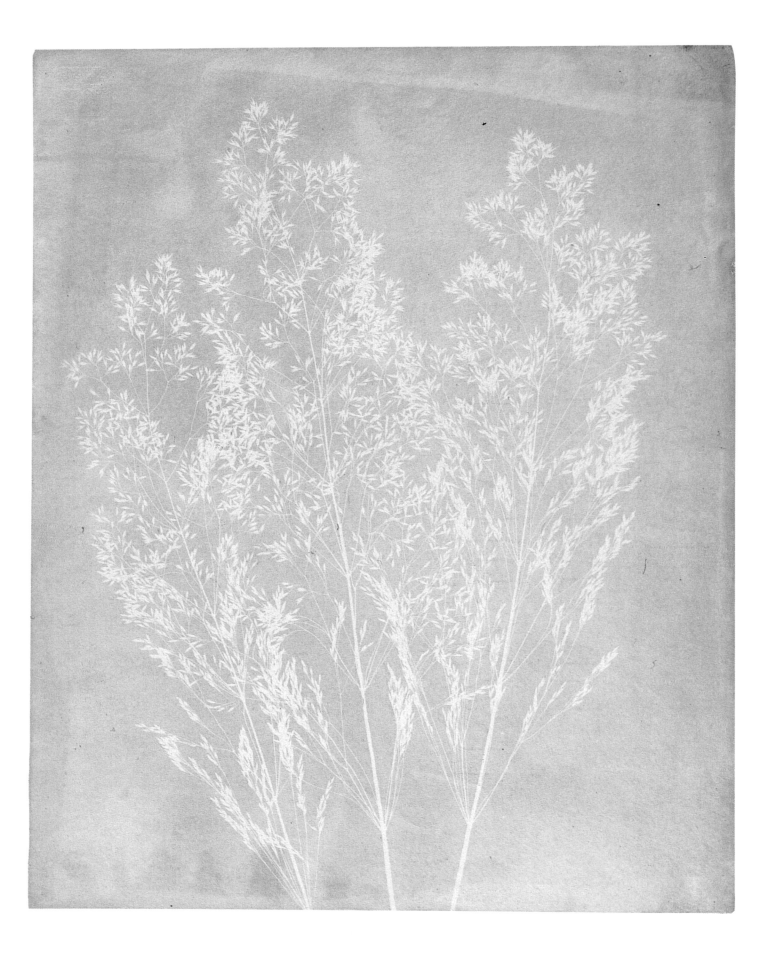

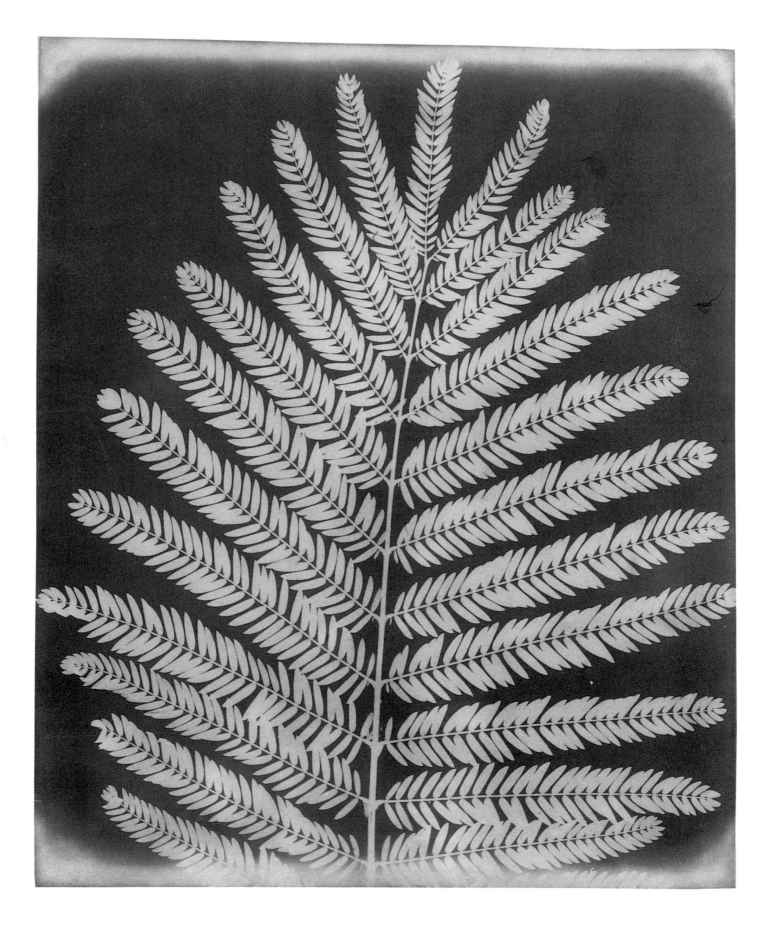

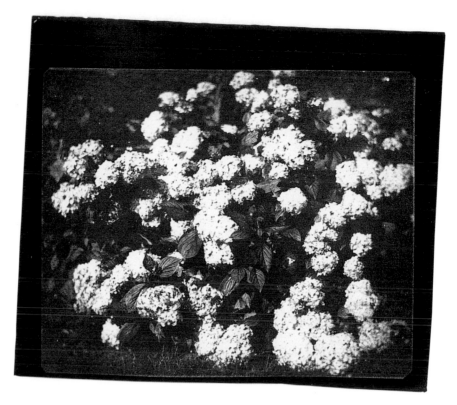

(Opposite) *Botanical specimen*,
photogenic drawing negative,
ca. 1839
7¹³/₃₂ x 8²⁹/₃₂" (18.8 x 22.6 cm.)

(Right) *Bush of hydrangea in flower*,
salt paper print from a calotype
negative, ca. 1841
4³/₈ x 3¹³/₁₆" (11.1 x 9.7 cm.)

(Bottom) *Multi-boled tree, Carclew
Park, Cornwall*, salt paper print
from a calotype negative, ca. 1842
8²⁷/₃₂ x 7¹/₂" (22.5 x 19 cm.)

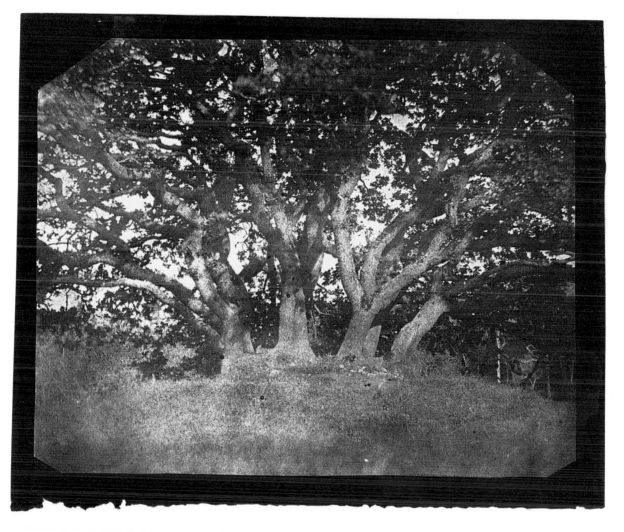

(Left) *Shrubs*, salt paper print from a calotype negative, ca. 1842
4⁷/₁₆ x 3¹³/₁₆" (11.3 x 9.7 cm.)

(Below) *The Geologists*, Chudleigh, Devon, salt paper print from a calotype negative, ca. 1843
4⁷/₁₆ x 3¹³/₁₆" (11.2 x 9.6 cm.)

(Opposite) *Oak tree in winter*, Lacock Abbey, salt paper print from a calotype negative, ca. 1843
7¹/₄ x 8¹³/₁₆" (18.4 x 22.4 cm.)

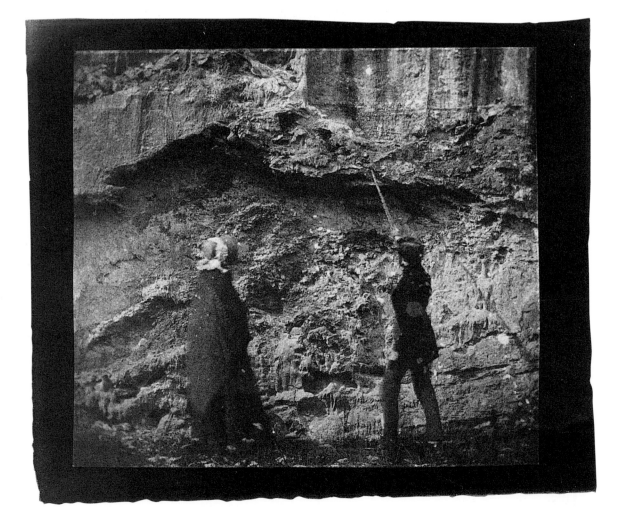

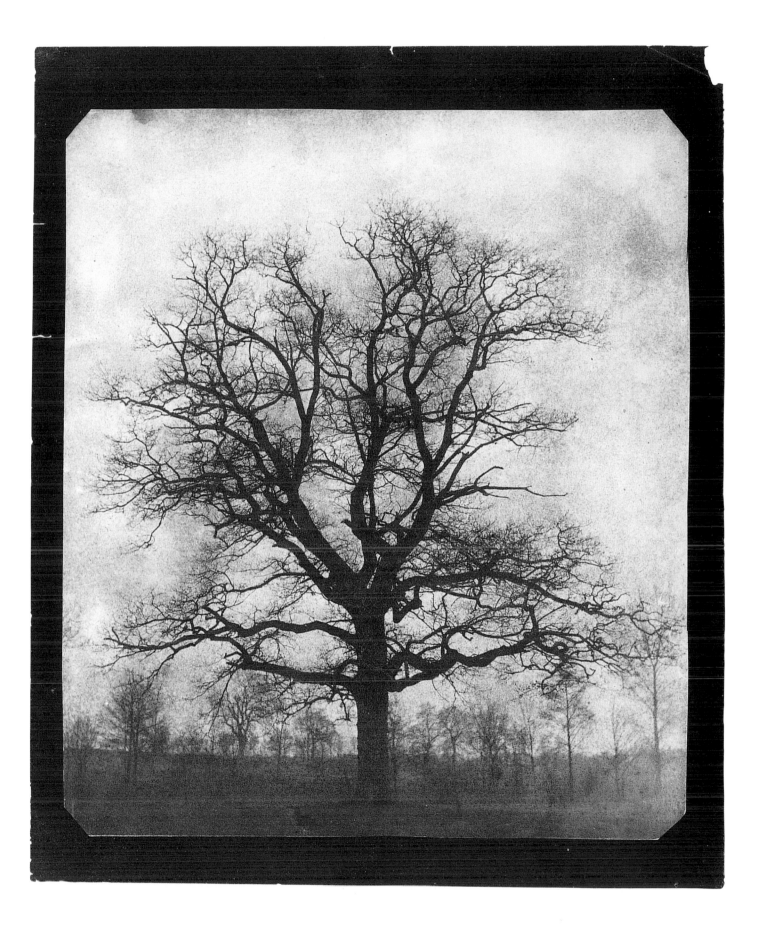

PEOPLE, PLACES, AND THINGS

I long to have such a memorial of every being dear to me in the world. It is not merely the likeness which is precious in such cases—but the association and the sense of nearness involved in the thing . . . the fact of the very shadow of the person lying there fixed forever!
—Elizabeth Barrett, extract from a letter to Mary Russell Mitford, 1843

Talbot often alluded to genres from the history of painting. Still life, portraiture, tableau vivant, the conversation piece, and the landscape were some of the conventions suggested. Talbot's approach to picture making was never simply arbitrary or literal. The use of metaphor and symbolism coupled with his fascination for written and visual language, suggest that these pictures are more poetic and literary renderings of things. Like many of his pictures, they are not easily reconciled to one set of values or interpretation.

Scenes from the ancestral home at Lacock constitute a large percentage of Talbot's archive. Studies of workmen's tools, ephemeral structures like haystacks, and activities like chopping wood, reflect the process of labor and elements of the rural economy. In contrast images of shelves of objects and table settings, neatly arranged and carefully lit are part of another set of rituals; they reveal the social and cultural habits of the Talbot family and the landed gentry in general. His photographs of personal possessions and domestic scenes also provide evidence of material wealth. Such photographs anticipated the later conventions of the family album.

Talbot was most active as a photographer between 1840 and 1843, recording objects and settings of objects, places visited, and people. He took his first portraits in 1840. Exposure times of up to several minutes were necessary, often making facial expressions indiscernible. Talbot often went to great lengths to stage settings of objects, as well as fictional scenes in photographs like *The Fruit Sellers* (back jacket).

The Talbot Collection at the National Museum of Photography, Film and Television contains a number of albums that may have been assembled as a form of

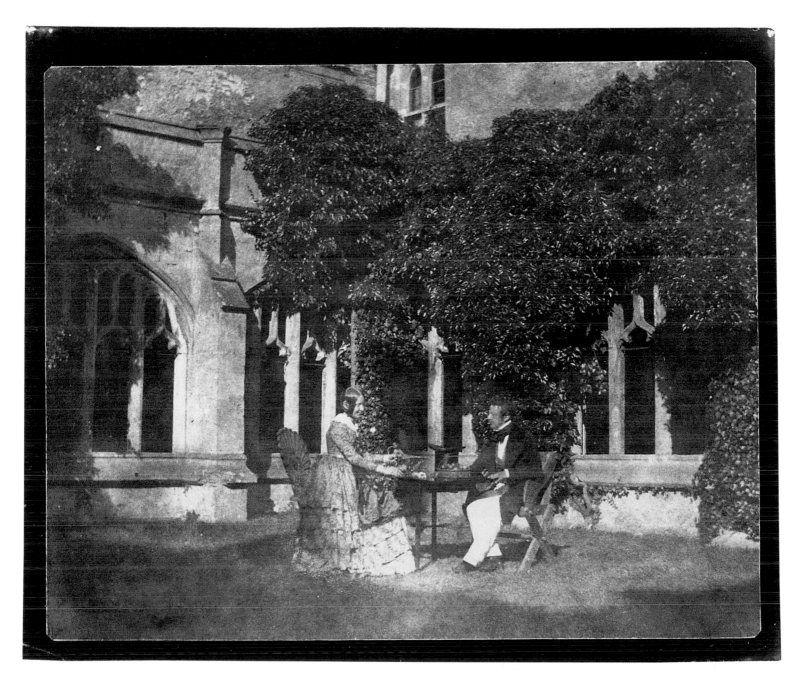

Calvert Jones and Constance Talbot,
salt paper print from a calotype negative,
ca. 1843
8$^{13}/_{16}$ x 7$^{5}/_{32}$" (22.4 x 18.2 cm.)

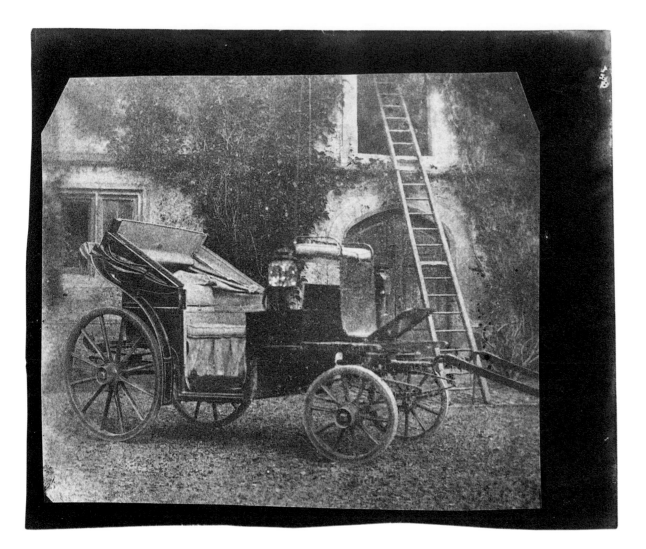

Carriage and ladder, Lacock Abbey,
salt paper print from a calotype
negative, ca. 1841
4⁹/₁₆ x 3⁹/₃₂" (11.6 x 9.9 cm.)

"trade catalogue" to demonstrate the potential of photography to those interested in licensing the process. They can also be seen as part of the nineteenth-century fashion for compiling albums as a form of diary. These albums are like portable museums, each offering a kind of microcosm of the world as image. Susan Stewart, in her book *On Longing* (1993) explores the importance of narrative as part of the process of acquisition and display of souvenirs: "The photograph as souvenir is a logical extension of the pressed flower, the preservation of an instant in time through a reduction of physical dimensions and a corresponding increase in the significance supplied by means of narrative."[24] For Talbot, the studies of family members and the contents of his home at Lacock, are essential for understanding the narrative of photographic experimentation, but also an intimate distance from which to explore social history through photography.

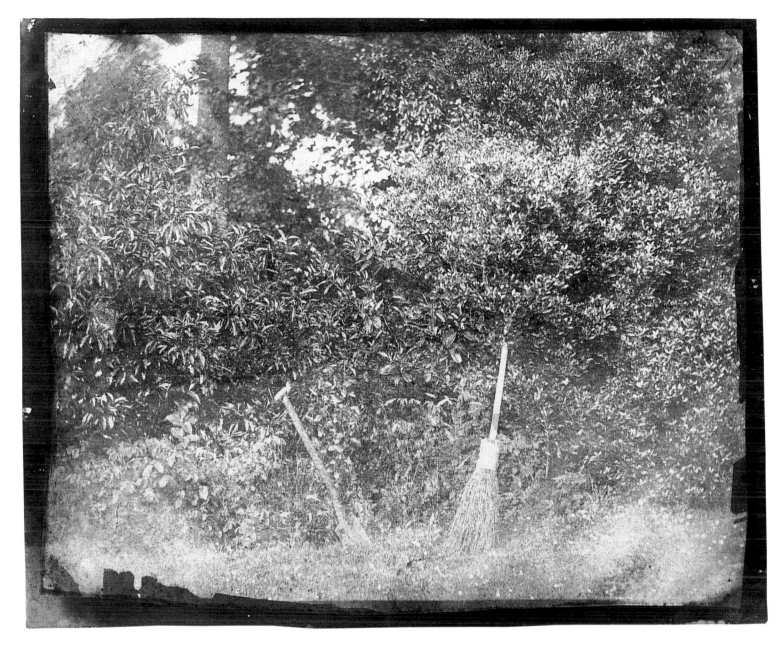

Broom and spade, salt paper print
from a calotype negative, ca. 1841
8²⁹/₃₂ x 7⁹/₃₂" (22.6 x 18.5 cm.)

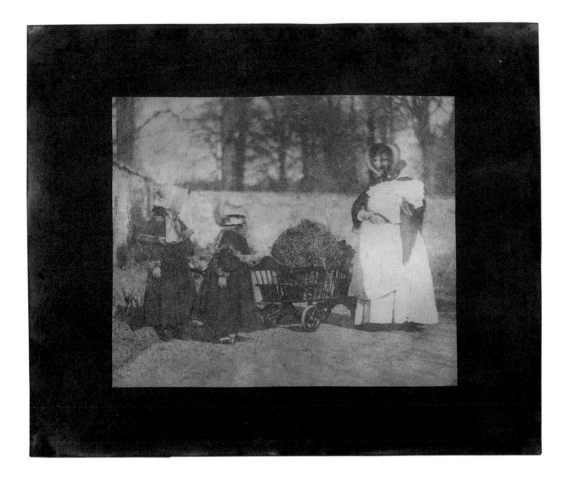

(Left) *Two daughters, toy hay cart,* salt paper print from a calotype negative, ca. 1842
$8^{13}/_{16}$ x $7^7/_{16}$" (22.4 x 18.9 cm.)

(Bottom) *Constance and daughters,* salt paper print from a calotype negative, ca. 1841
$8^{27}/_{32}$ x $7^{13}/_{32}$" (22.5 x 18.8 cm.)

(Opposite top) *Tabletop with vase and china,* salt paper print from a calotype negative, ca. 1841
7 x $4^1/_4$" (17.8 x 10.8 cm.)

(Opposite bottom) *Table set for tea,* salt paper print from a calotype negative, ca. 1841
$7^5/_{16}$ x $4^7/_{32}$" (18.6 x 10.7 cm.)

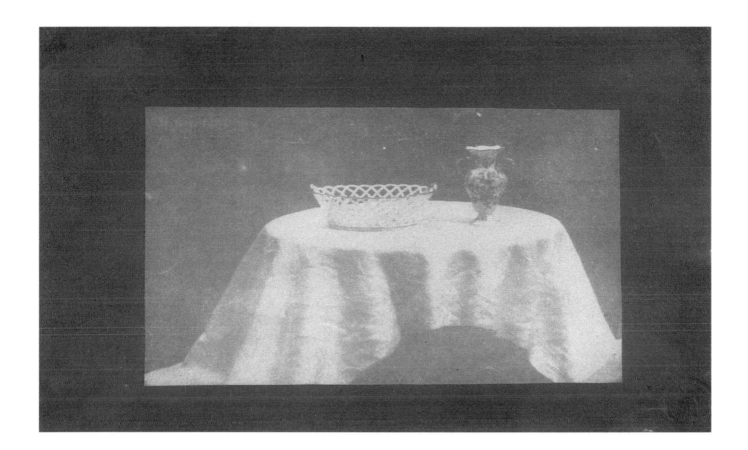

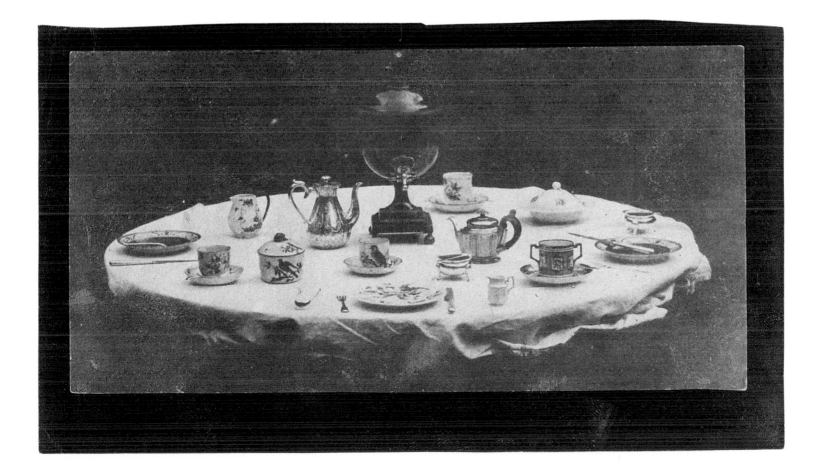

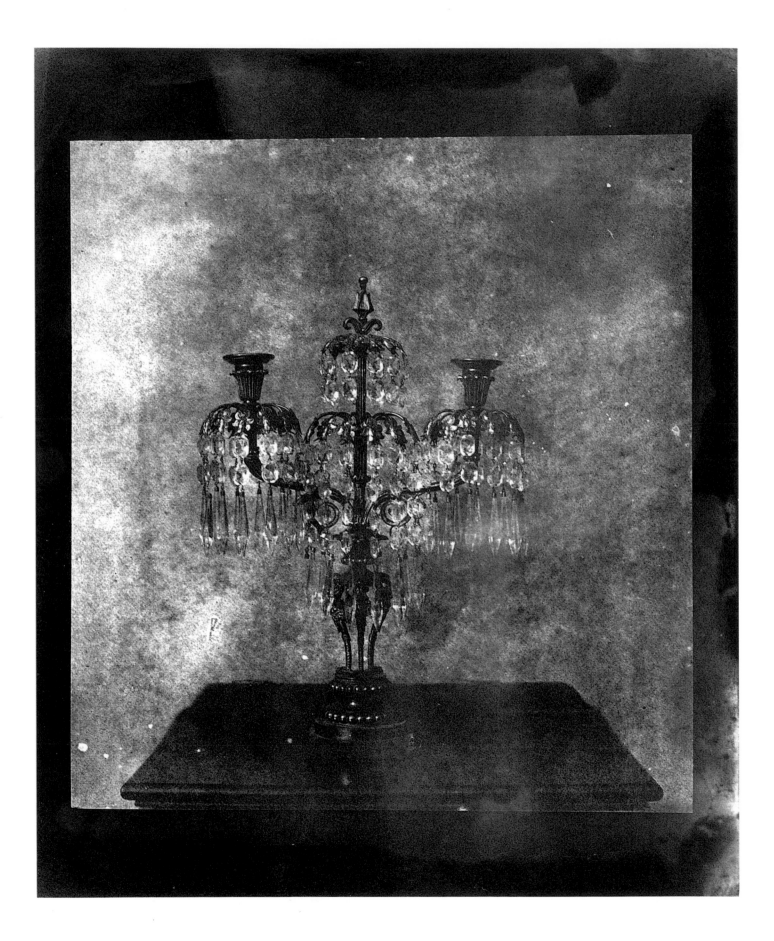

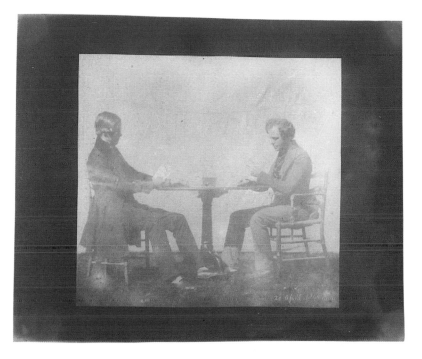

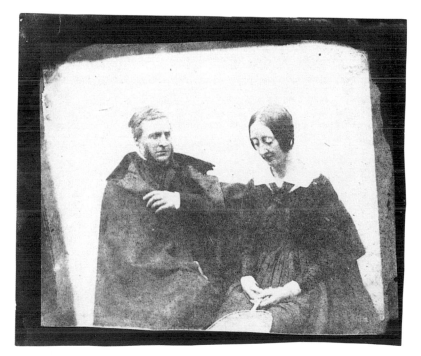

(Opposite) *Candelabra*,
salt paper print from a calotype negative, ca. 1843
7⁵/₁₆ x 8²⁹/₃₂" (18.6 x 22.6 cm.)

(Above) *Two women (Lady Elizabeth and Horatia)*,
salt paper print from a calotype negative, ca. 1843
4¹/₁₆ x 7⁹/₃₂" (11.3 x 18.5 cm.)

(Top right) *Henneman playing cards with Pullen*,
salt paper print from a calotype negative, ca. 1842
8¹⁵/₁₆ x 7³/₈" (22.7 x 18.7 cm.)

(Bottom right) Thomas Gaisford and Horatia,
salt paper print from a calotype negative, ca. 1843
4⁹/₃₂ x 3¹¹/₁₆" (10.9 x 9.3 cm.)

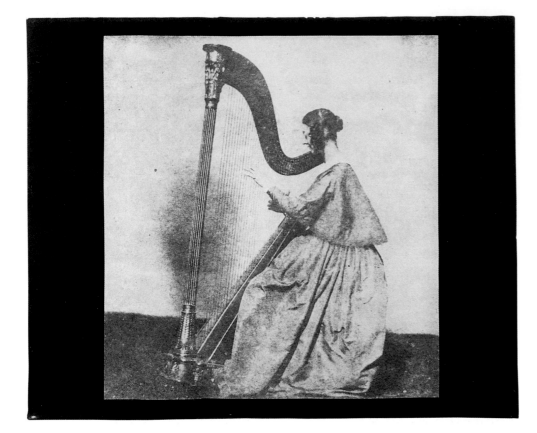

(Left) *Horatia at her harp*,
salt paper print from a calotype
negative, ca. 1843
8³/₁₆ x 7¹/₄" (22.4 x 18.4 cm.)

(Below) *Lady Elisabeth on chaise
lounge*, salt paper print from a
calotype negative, ca. 1842
8²³/₃₂ x 7⁵/₃₂" (22.1 x 18.2 cm.)

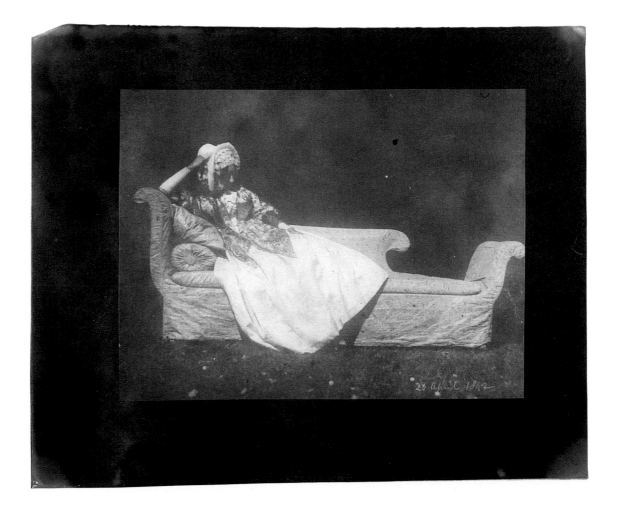

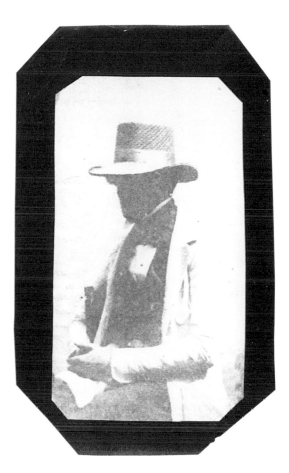

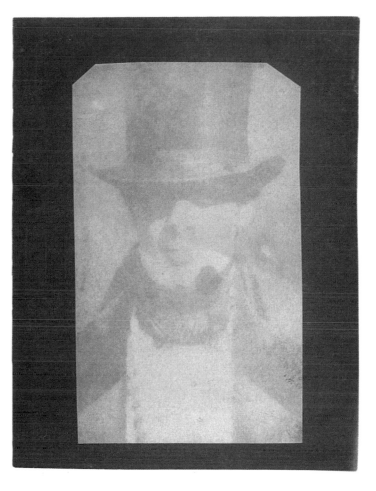

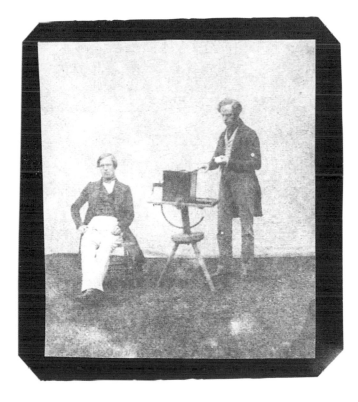

(Above) *Man, silhouetted face*,
salt paper print from a calotype
negative, ca. 1842
2⅝ x 4¹³/₃₂" (6.7cm. x 11.2 cm.)

(Top right) *Man in top hat*,
salt paper print from a calotype
negative, ca. 1842
3¹¹/₁₆ x 4¾" (9.3 x 12.1 cm.)

(Top right) *Henneman taking
Pullen's portrait*,
salt paper print from a calotype
negative, ca. 1843
3¹¹/₃₂ x 3²³/₃₂" (8.5 x 9.4 cm.)

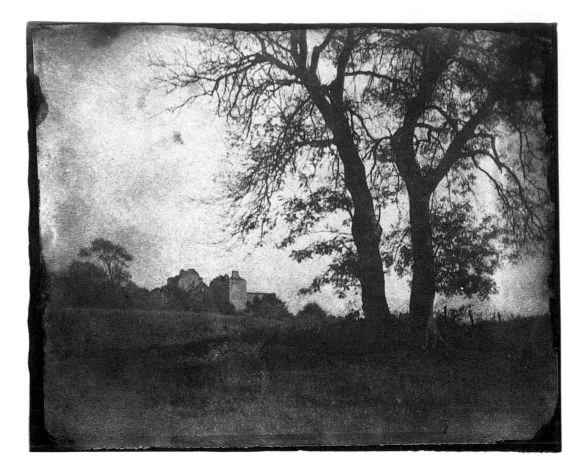

(Left) *Landscape with trees and ruin*,
salt paper print from a calotype
negative, ca. 1845
$8^{31}/_{32}$ x $7^9/_{32}$" (22.8 x 18.5 cm.)

(Below) *Trees with reflection*,
salt paper print from a calotype
negative, ca. 1843
$1^7/_8$ x $7^{23}/_{32}$" (4.8 x 19.6 cm.)

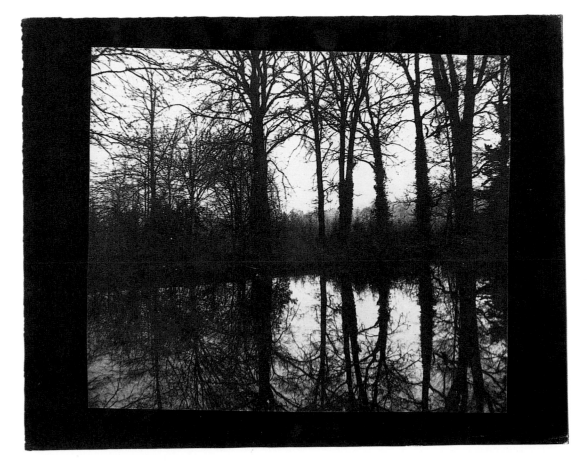

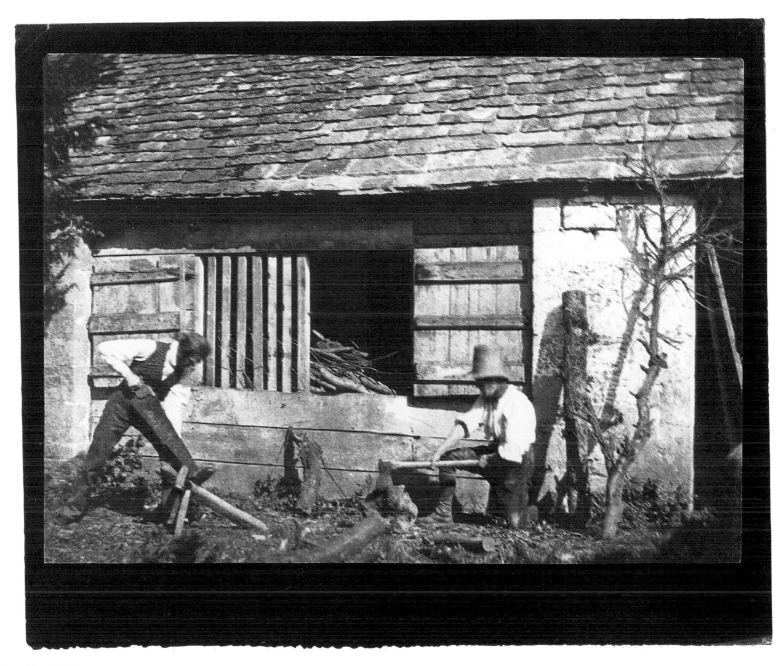

The Woodcutters:
Pullen and Henneman,
salt paper print from a calotype
negative, ca. 1843
$8^{15}/_{16}$ x $7^{13}/_{32}$" (22.7 x 18.8 cm.)

FACSIMILES

Upon one occasion, having made an image of a piece of lace of an elaborate pattern, I showed it to some persons at the distance of a few feet, with the enquiry, whether it was a good representation? when the reply was, "That they were not to be so easily deceived, for that it was evidently no picture, but the piece of lace itself."
— W. H. F. Talbot, *Some Account of the Art of Photogenic Drawing*, 1839

Talbot often took photographs to demonstrate the medium's ability to create copies or facsimiles of objects and printed materials. Indeed one of the first roles imagined for the new process of photogenic drawing was as an alternative to printing. The realization that photography could generate copies of an original initially led to the production not of simulacra, as in the case of Talbot's story about the mistaken identity of a photograph of lace, but of copies that retained an unprecented level of detail of the original. This was achieved by placing the object directly in contact with the paper—"superposition"—and creating a negative image through a relatively short exposure. By this technique, historical documents could be reproduced and made widely available for study, and manufacturer's designs could be copied for sample catalog. Thus photography could both preserve the past and participate in the industrial present. In this respect it accorded with the wider mechanization of traditional forms of production that took place during the nineteenth century. Perceived as a semi-automated process, photography sat comfortably within the industrial expansion of the time.

Talbot delighted in visual demonstrations of the photographic process as an alternative to established printing techniques. Lithography and engraving were laborious; photography could render the myriad details and nuances in a manuscript or sample of lace in a matter of minutes. Scraps of patterned fabric and paper were also copied, as well as plates from books, which spoke both of his broad interests and of the traditions of book illustration. Lithographed engravings were removed from the bindings of books, waxed, and used as negatives. Copied as salt prints, these images performed the necessary task of highlighting the potential of one process over another. As copies of copies, they not only indicated the efficiency of the photographic process but also moved toward the photograph's later role as a unit of knowledge in the syntax of the book. Talbot saw in photography not only an economy of labor but a heuristic device by which the hidden or unnoticed dimensions of the world could be made visible.

(Opposite) *Lace,*
salt paper print from a photogenic drawing negative, ca. 1840
$9^{3}/_{32}$ x $7^{3}/_{8}$" (23.1 x 18.7 cm.)

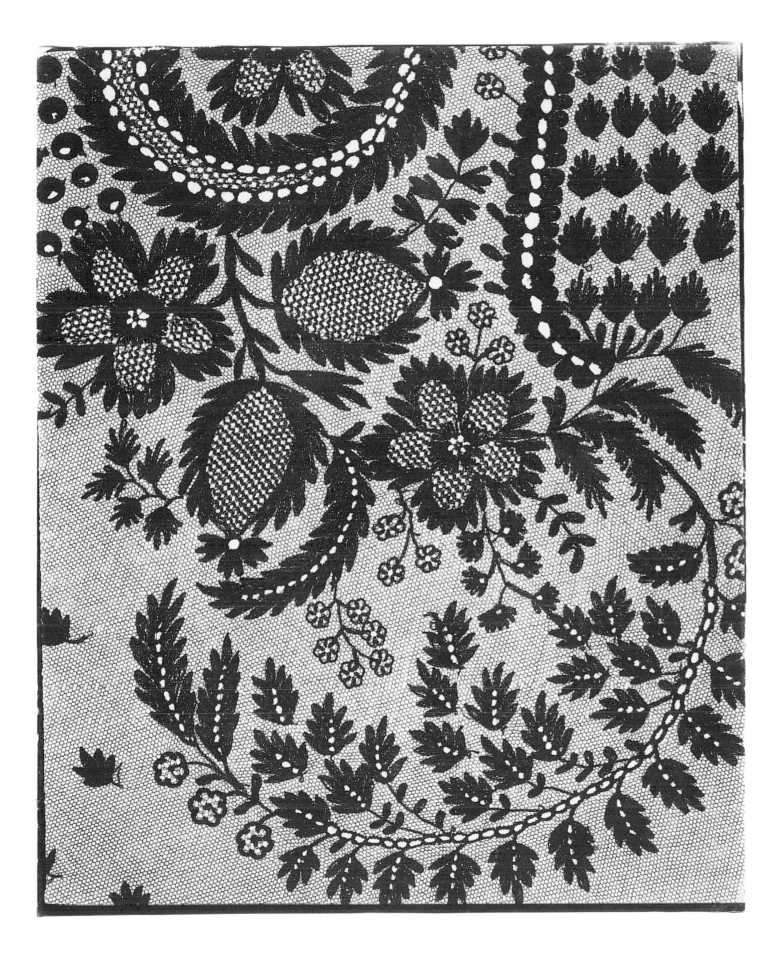

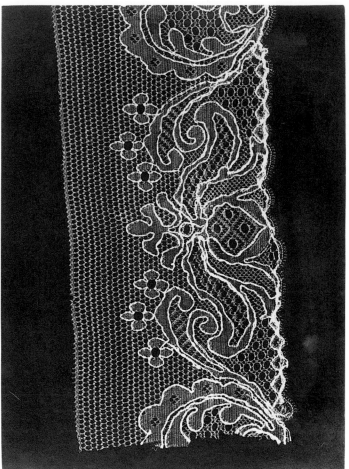

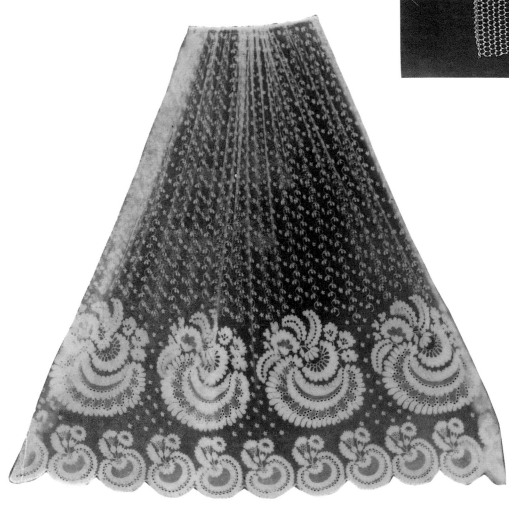

(Top left) *Copy of Rococo pattern*, salt paper print from a photogenic drawing negative, ca. 1841
3¹/₂ x 3³/₄" (8.9 x 9.5 cm.)

(Above) *Lace*, waxed salt paper print from a photogenic drawing negative, ca. 1840
5⁷/₁₆ x 5⁹/₁₆" (13.8 x 14.1 cm.)

(Left) *Lace*, photogenic drawing negative, ca. 1840
8¹/₈ x 5²⁹/₃₂" (20.6 x 15 cm.)

Copy of handwritten poem,
salt paper print, ca. 1841
7⁹/₁₆ x 5¹¹/₃₂" (19.2 x 13.6 cm.)

By copying words and images, Talbot considered the photograph in relation to existing methods of reproduction, such as handwriting, lithography, engraving, and letterpress printing. He carefully orchestrated these uses, comparing marks made by hand with marks made by machine, and offering reflexive statements on the inherent value of his photographic process in relation to both. His reproduction of texts in images such as *Imitation of Printing,* ca. 1844 (p. 40), and a published version of his essay *Some Account of the Art of Photogenic Drawing* underline photographic reproduction in the text represented. A poem by Thomas Moore shows a more subtle comparison between media: the original hand-written version has been photographed and the words "Common Ink" have been written—in ink—on the surface of the print (p. 74). Here is an obvious yet compelling engagement with the facsimile dimension of photography.

It is well known that Talbot felt disgruntled by Daguerre's status in relation to the origins of photography. By copying daguerreotypes, he made a simple yet poignant claim for photography on paper, and for the calotype process. A hand-written label used as a negative, bearing the words "Specimen of Talbotype (or Calotype) Photogenic Drawing (p. 40)," performed a similar task of underlining what was unique about Talbot's negative/positive process.

Photography entered the visual economy of the nineteenth century providing a new level of realism that redefined the role of the artist, and brought with it increased production. Subsequently ideas of the original and the copy were to change.

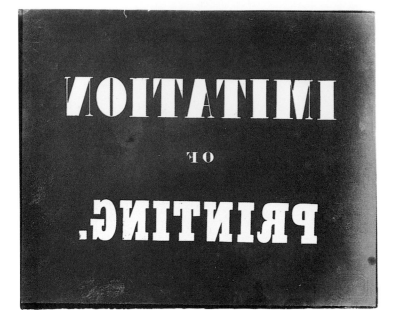 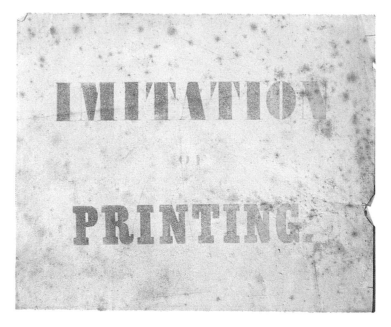

(Above) *Copy of printed label:*
"Imitation of Printing,"
photogenic drawing negative,
and salt paper print, ca. 1844
8³¹/₃₂ x 7¹⁵/₃₂" (22.8 x 19 cm.),
8³¹/₃₂ x 7¹⁵/₃₂" (22.8 x 19 cm.)

(Left) *Handwritten label,*
photogenic drawing, paper
negative, ca. 1843
3³/₈ x 1⁵/₈" (8.6 x 4.1 cm.)

(Below) *Handwritten label,*
photogenic drawing, salt paper
print, ca. 1843
4⁷/₁₆ x 2⁷/₃₂" (11.3 x 5.6 cm.)

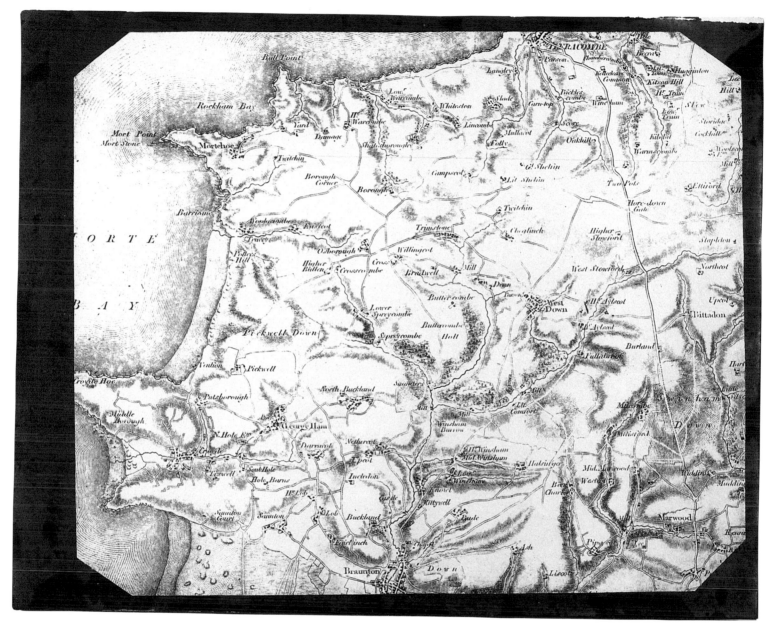

Copy of map of the environs of
Ilfracombe, Devon,
salt paper print from a photogenic
drawing negative, ca. 1839
9²/₁₆ x 7⁵/₁₆" (23.1 x 18.5 cm.)

THE PENCIL OF NATURE
Photography, Industry, and the Book

The plates of the present work are impressed by the agency of Light alone, without any aid whatever from the artist's pencil. They are the sun-pictures themselves, and not, as some persons have imagined, engravings in imitation.

—W. H. F. Talbot, "Notice to the Reader," *The Pencil of Nature*, 1844–46

A wonderful illustration of modern necromancy.

—*The Athenaeum*, 1845

In a patent of 1843, Talbot described a system for mass-producing prints for publication. Later that year he began work on a proposed print workshop at Reading. Here photographs were to be printed, in large numbers, for books, journals, and print sellers. The Reading Establishment opened in 1844, and was managed by Talbot's former valet, Nicolaas Henneman. It was here that the prints were made for the first commercially produced book to be illustrated with photographs: Talbot's *The Pencil of Nature*. Reading was equidistant between London and Lacock Abbey, and benefited from the new Great Western Railway networks.

Over three years, the Establishment printed illustrations for a range of publications including *Sun Pictures in Scotland* (1845), *The Talbotype Applied to Hieroglyphics* (1846), and *The Annals of the Artists of Spain* (1847). One of the first commissions came from John Walter, chief proprietor of *The Times*, who required a photograph of a marble bust of his daughter, Miss Catherine Walter, who had recently died. This "portrait" was then tipped into the frontispiece of a privately printed commemorative bound book entitled *The Death Bed of C.M.W.* (1844).

The key project in this experiment in publishing and mass printing was *The Pencil of Nature*. Published over two years in six fascicles, each issue contained a series of photographically produced plates accompanied by a short text. The first volume included Talbot's essay "A Brief Historical Sketch of the Invention of the Art," followed by five salt prints made from calotype negatives. The publication as a whole was intended to familiarize the public with the various practical applications of photography. Competing with existing printing methods, *The Pencil of Nature* was a reflexive example of photography's illustrative potential.

(Opposite) *Nicolaas Henneman holding a copy of* The Pencil of Nature, *salt paper print from a calotype negative, ca. 1844* $5^{23}/_{32}$ x $7^{31}/_{32}$" (14.5 x 20.2.cm.)

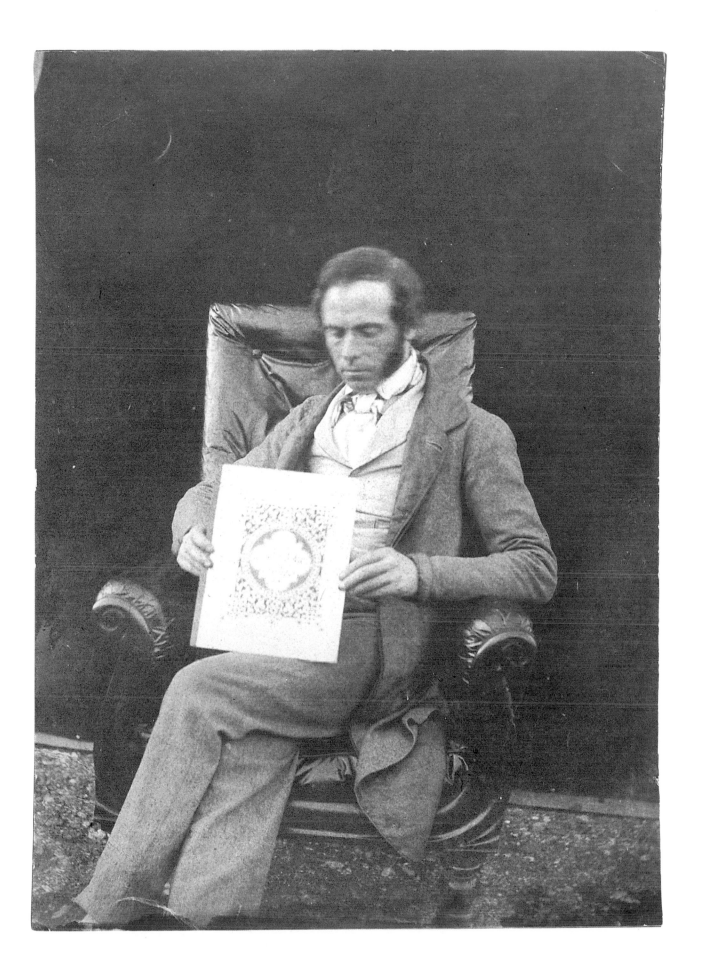

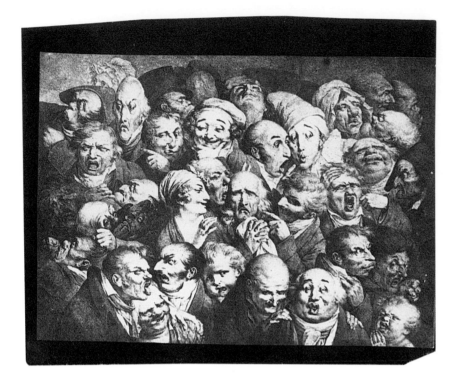

During the publication of *The Pencil of Nature*, Talbot embarked on another
photographically illustrated book that was quite distinct from his previous attempt
to classify photography: *Sun Pictures in Scotland* (1845), which introduced readers to
a Romantic potential in the medium, was dominated by pictures, contained little
text, and sought to evoke the writings and the descriptions of the Scottish land-
scape found in the work of Sir Walter Scott. In the early nineteenth century, travel-
ers in search of the picturesque were visiting parts of Scotland associated with
Scott, namely the Trossachs and Loch Katrine, the backdrop for his book *The Lady
of the Lake* (1810). Scott combined folk traditions and rural history with detailed
accounts of the Scottish landscape. Talbot's pictures can be seen as participating in
the growing tourist fascination with Scotland. The intellectual baggage that would
have accompanied these upper-class travelers would have included the works of
Wordsworth, Goethe, and Schiller.

Several books made at Reading have become historically important, including
The Annals of the Artists of Spain (1848), the first use of photography in the study of
art history. Yet these books were not financially successful. Since the printing was
affected by inconsistencies in the photographic process, impurities in the water, and
even by the weather (sunlight was essential for printmaking), quality was variable
and production was slow. The Establishment closed in 1847 and the business moved
to London.

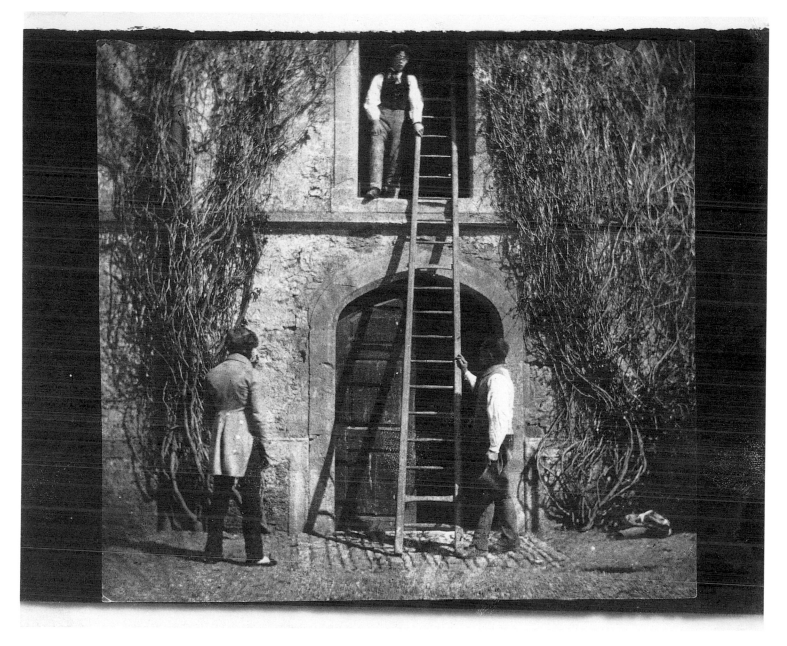

The Ladder (Plate xiv from *The Pencil of Nature*), salt paper print from a calotype negative, ca. 1845
8¹³/₁₆ x 7⁵/₁₆" (22.4 x 18.6 cm.)

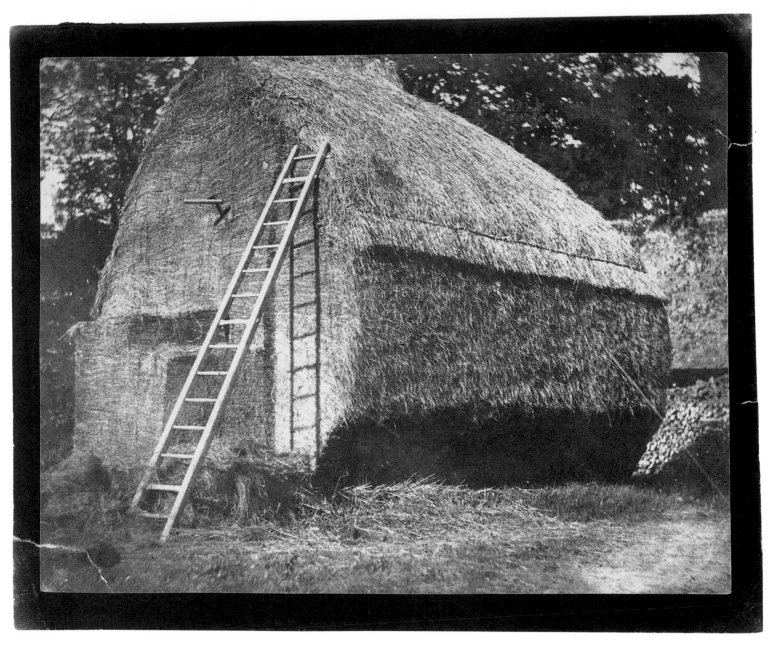

The Haystack (Plate x from *The Pencil of Nature*), salt paper print from calotype negative, ca. 1844
$9^{1}/_{32}$ x $7^{13}/_{16}$" (23.0 x 18.9 cm.)

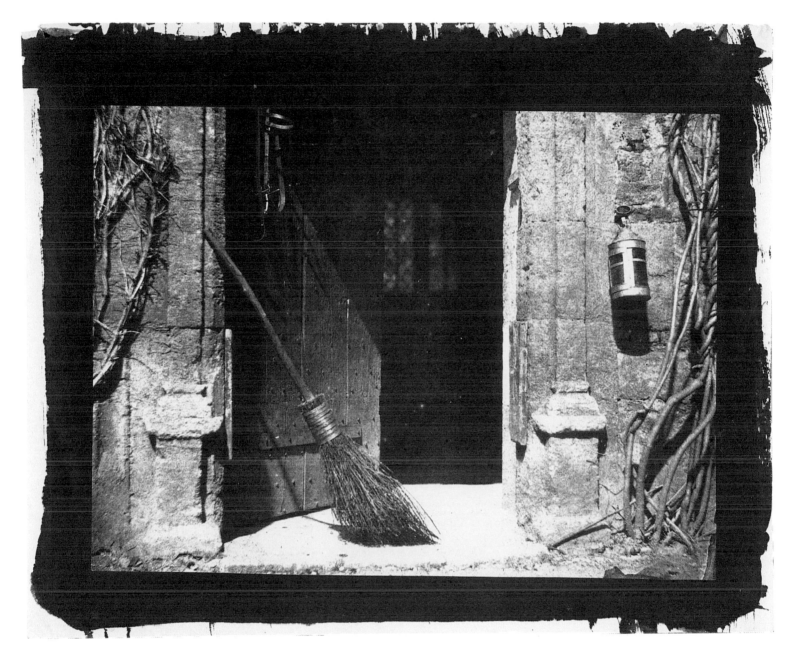

The Open Door (Plate VI from *The Pencil of Nature*), salt paper print
from calotype negative, ca. 1844
9³/₃₂ x 7⁷/₁₆" (23.1 x 18.9 cm.)

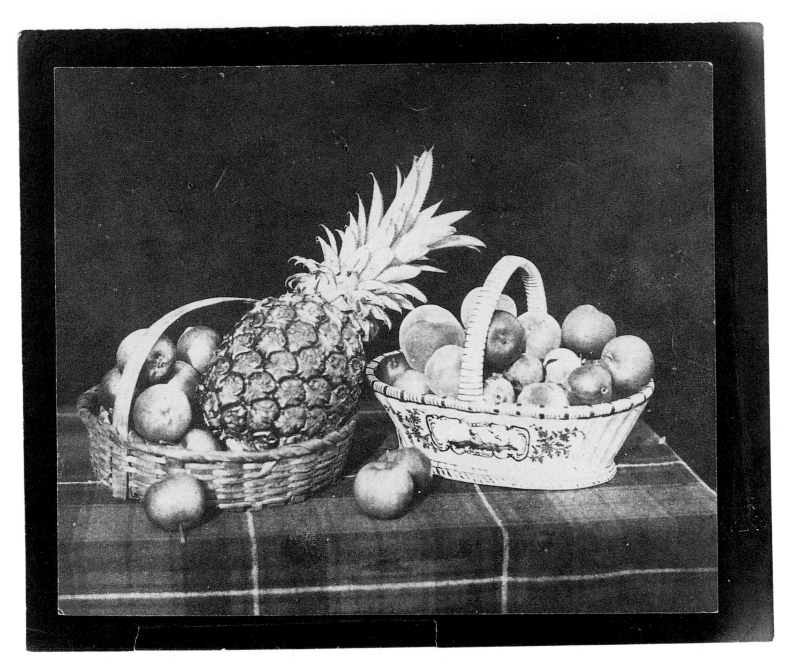

A *Fruit Piece* (Plate xxiv from
The Pencil of Nature), salt paper
print from a calotype negative,
ca. 1844
$9^7/_{32}$ x $7^9/_{32}$" (23.4 x 18.5 cm.)

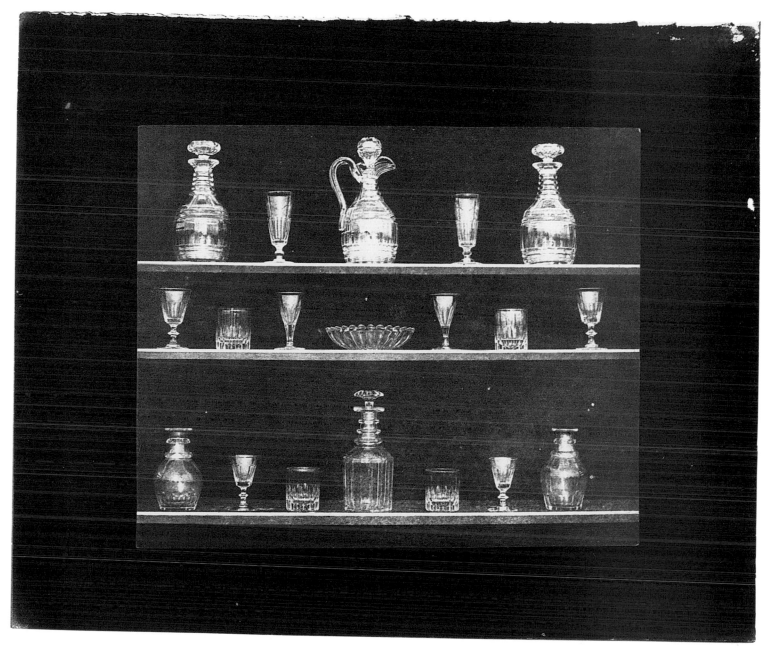

Articles of Glass (Plate IV from *The Pencil of Nature*), salt paper print from a calotype negative, ca. 1844
8²⁷/₃₂ x 7⁵/₁₆" (22.5 x 18.6 cm.)

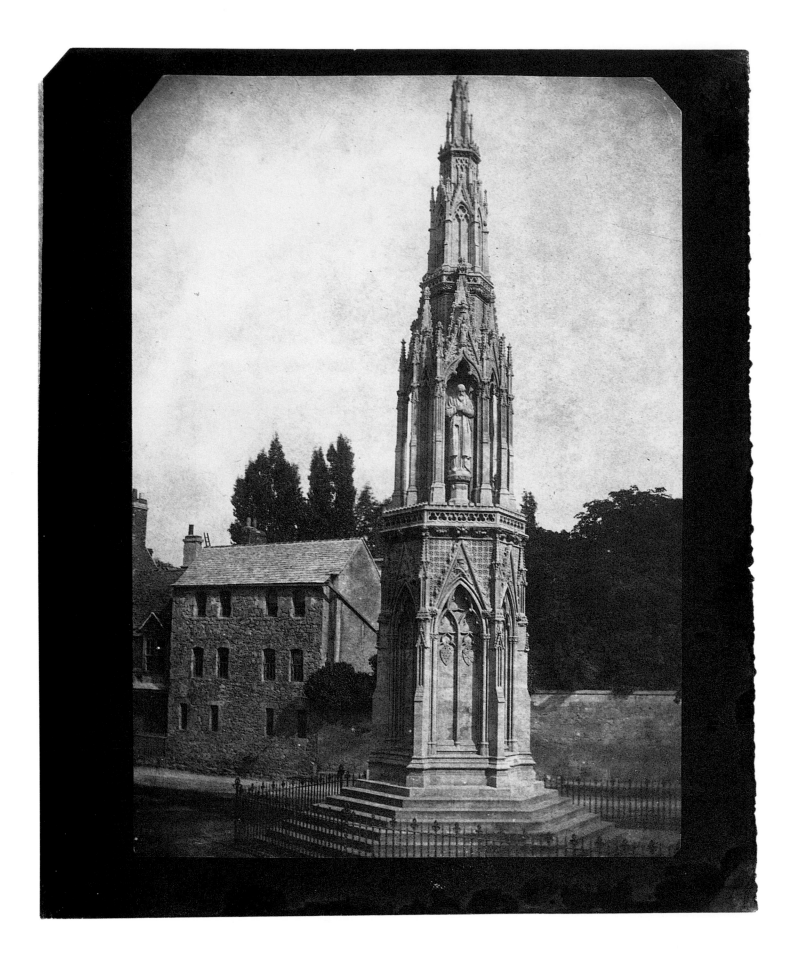

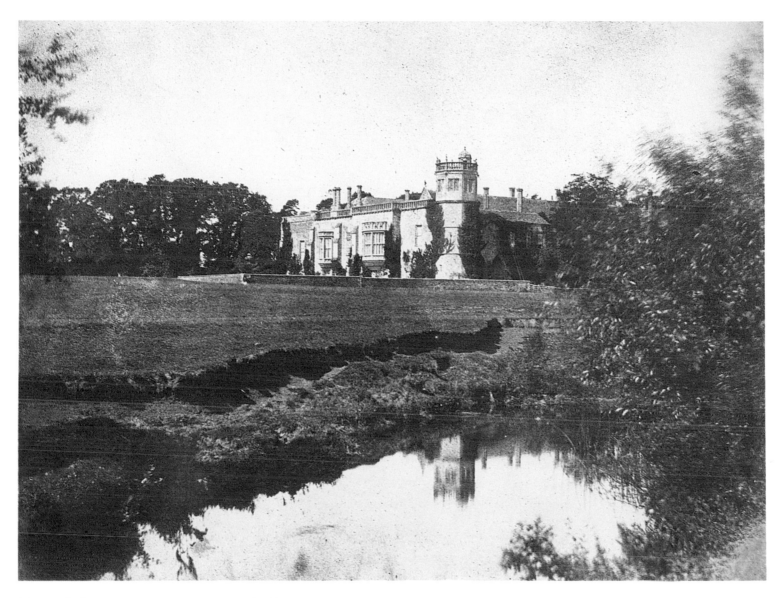

(Opposite) *The Martyrs' Monument,*
Oxford, (Plate XXI from *The Pencil
of Nature*), salt paper print from a
calotype negative, ca. 1843
8¹³/₁₆ x 7¹/₂" (22.3 x 19 cm.)

Lacock Abbey (Plate XV from *The
Pencil of Nature*), salt paper print
from a calotype negative, ca. 1844
7³¹/₃₂ x 5¹⁵/₁₆" (20.2 x 15.1 cm.)

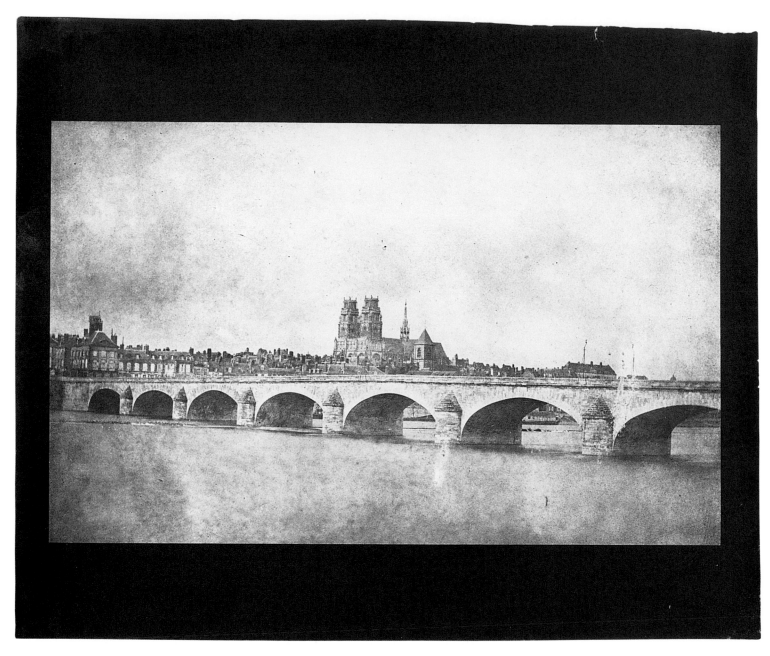

The Bridge of Orleans, (Plate XII
from *The Pencil of Nature*),
salt paper print from a calotype
negative, ca. 1843
$8^{27}/_{32}$ x $7^{3}/_{8}$" (22.5 x 18.7 cm.)

Part of Queens College, Oxford,
(Plate 1 from *The Pencil of Nature*),
salt paper print from a calotype
negative, ca. 1843
9^{1}/$_{8}$ x 7^{3}/$_{8}$" (23.2 x 18.7 cm.)

THE ART OF REPRODUCTION

Photography is admirably adapted for sculpture; and a noble gallery of all that is great in that art might readily be produced in such splendid imitations. . . . Mr. Talbot's instructions as to the best means for taking these 'likenesses' are of high practical value.

—*Literary Gazette*, 1844

During the nineteenth century the photograph, like the museum, introduced a different attitude towards the way in which works of art and art history were consumed. The copying of artworks had previously been dominated by lithography and the making of casts. The photograph would subsequently become an alternative to copying, and a new agent of collecting and display.

Talbot noted how the original could be preserved and "multiplied to any extent"[25] through the facsimile method of superposition, and the scale of artworks altered by moving the camera further away from, or closer to, the original object.

Studies of classical statuary demonstrated variations in light and composition. Remarking on this characteristic Talbot wrote, "it becomes evident how very great a number of different effects may be obtained from a single specimen of sculpture."[26] The original therefore, was open to other readings through the photograph.

Casts were in vogue during the nineteenth century and often displayed in the homes of the rich and educated, associated as they were with good taste and high cultural values. A marble bust, which Talbot named Patroclus, the Greek hero of the Trojan War and loyal friend of Achilles, became a regular subject. The play of light, the dramatization of the agonized expression, made for a series of powerful portraits. Patroclus was photographed inside Lacock Abbey, but also on its own in the makeshift studio setting in the grounds of Talbot's home. Its white reflective surface made it an ideal subject for experiments in the technical and intellectual possibilities of photography.

The photographic reproduction of art works as André Malraux would describe some hundred years later, suggested that ". . . a 'Museum without Walls' is coming into being, and (now that the plastic arts have invented their own printing-press) it will carry infinitely farther that revelation of the world of art, limited perforce, which the 'real' museums offer us within their walls".[27] Talbot's first copies of paintings, engravings, and classical statuary can be seen as the genesis of this new museum space.

Study of bust of Patroclus, (Plate XVII from *The Pencil of Nature*), salt paper print from a calotype negative, ca. 1841 7⁹/₃₂ x 8²⁷/₃₂" (18.5 x 22.5 cm.)

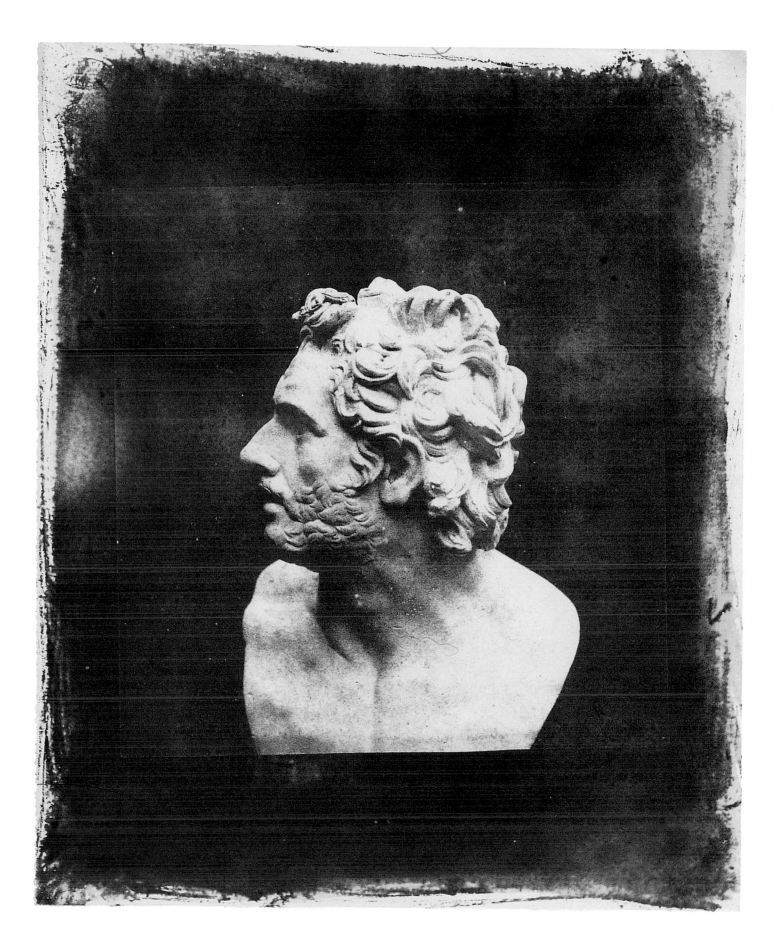

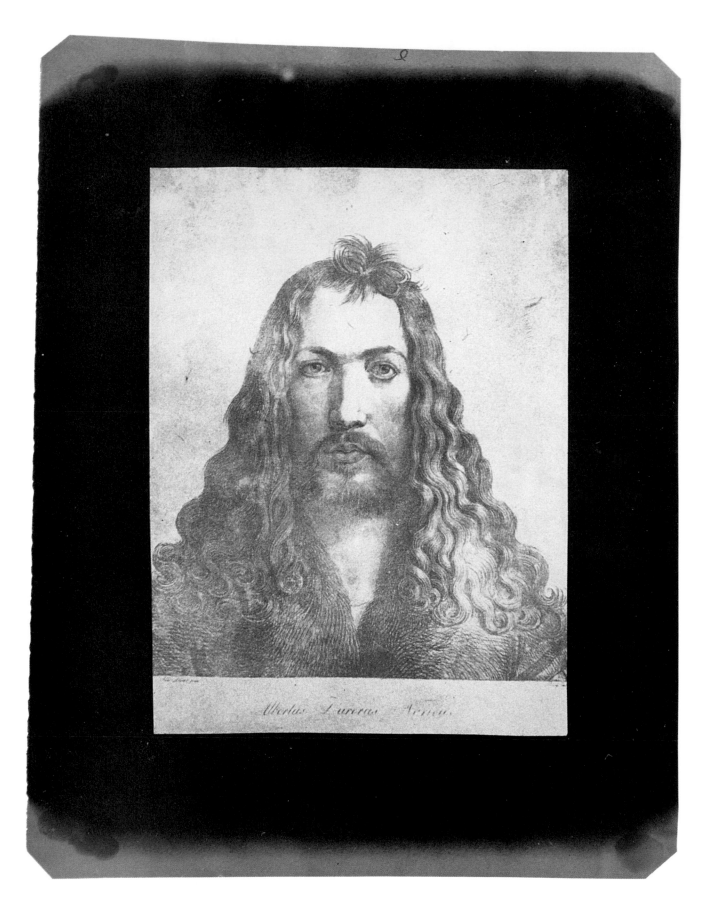

Albertus Dürerus Noricus

(Opposite) *Copy of a print: 'Self-portrait of the artist' by Albrecht Dürer*, salt paper print from a photogenic drawing negative, ca. 1843
6⁷/₈ x 8²⁵/₃₂" (17.5 x 22.3 cm.)

(Right) *Interior view of the Oriel Window at Lacock Abbey, with the bust of Patroclus*, photogenic drawing negative, ca. 1839
6¹¹/₃₂ x 6¹³/₁₆" (16.1 x 17.3 cm.)

(Below) *Study of bust of Patroclus*, salt paper print from a calotype negative, ca. 1842
9¹/₁₆ x 7³/₃₂" (23.0 x 28.0 cm.)

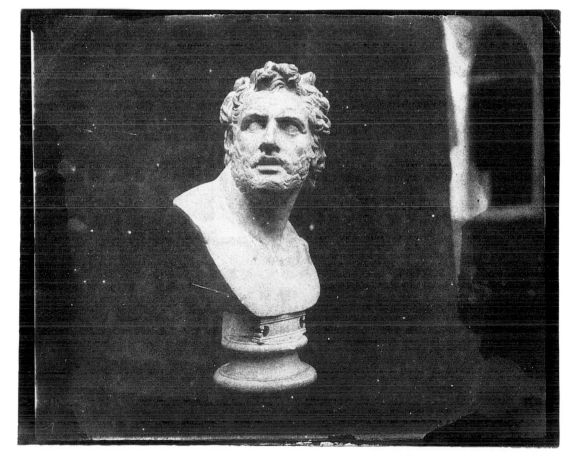

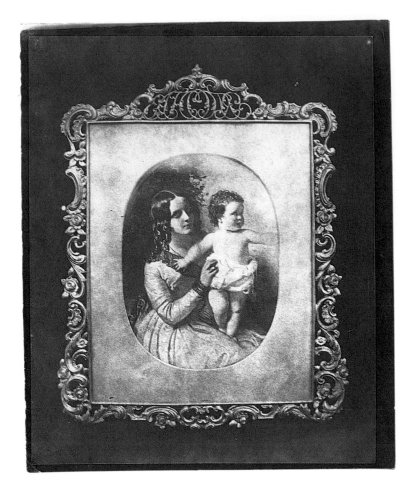

(Above left) *Copy of a painting of a woman and child*, salt paper print from a calotype negative, ca. 1845 7⁵/₁₆ x 8²⁷/₃₂" (18.6 x 22.5 cm.)

(Above) *Detail of a painting: Woman and child*, salt paper print from a calotype negative, ca. 1845 3³¹/₃₂ x 4⁷/₁₆" (10.1 x 11.3 cm.)

(Left) *Copy of a painting, "Neopolitan Conveyance,"* Lacock Abbey, salt paper print from a calotype negative, ca. 1843 9¹/₁₆ x 7¹⁵/₃₂" (23 x 19 cm.)

Bust of Venus, salt paper print from
a calotype negative, ca. 1841
$8^{29}/_{32}$ x $7^{9}/_{32}$" (22.6 cm .x 18.5 cm.)

ARTIFACTS

Etymology is the history of the languages of nations it explains their manners and customs, and throws light upon their ancient migrations and settlements. It is the lamp by which much that is obscure in the primitive history of the world will one day be cleared up. At present much that passes for early history is mere vague speculation: but in order to build a durable edifice upon a firm foundation, materials must be carefully brought together from all quarters and submitted to the impartial and intelligent judgment of those who are engaged in similar inquiries.

—W. H. F. Talbot, *English Etymologies*, 1847

Published during the same year as the public announcement of photography, *The Antiquity of the Book of Genesis, Illustrated by Some New Arguments* is emblematic of Talbot's engagement with lost civilizations through the written word. For Talbot, decoding the words and myths of antiquity could lead to a better understanding of those cultures. Photography could assist in the interpretation of history in other ways.

In 1840, the French physicist Jean Baptiste Biot wrote to Talbot to say that he was "charmed with the distinctness and accuracy" of a piece of Hebrew text (p. 62) that the photographer had sent to him. This photographic facsimile had created a great deal of interest among Biot's colleagues, clearly showing how artifacts and manuscripts could be copied and circulated for study. Talbot's photographs of historical subjects were rarely about one thing; they carried with them the traces of other pursuits, other kinds of engagement with a world or worlds from which he was spatially and temporally removed but that he looked to animate through the photographic document. In a plate of the Tower of Lacock Abbey in *The Pencil of Nature*, ca.1844, Talbot suggests that photography can help with the preservation and interpretation of history. Indeed he uses certain pictures to relay incidents in the history of Lacock Abbey, including the ghost of a nun with a bleeding finger, and a distant relative who jumped from a window into her lover's arms only to render him unconscious. Talbot wrote extensively on the history and translation of ancient and classical languages, and was one of a small number of scholars able to decipher cuneiform scripts. He was the first to use photography in the study of languages. In 1846 he published a pamphlet, *The Talbotype Applied to Hieroglyphics*, containing photographs of a handwritten translation of hieroglyphics by Samuel Birch of the British Museum. To further aid the study of artifacts, Talbot suggested that photographers replace "copyists" at archaeological sites, whose main job was to document aspects of the escavation, as drawings, for recording purposes and for future reference.

(Opposite) *Copy of a translation of hieroglyphic tablet*, salt paper print from a calotype negative, ca. 1845 $8^{27}/_{32}$ x $7^{13}/_{32}$" (22.5 x 18.8 cm.)

The Talbotype applied to Hieroglyphics —
Tablet at Ibrim — discovered 27th Decr. 1845 by Mr. A.C. Harris — forwarded to
the undersigned, and communicated by Mr. Saml. Birch to the R. Soc. of Literature,
with Translation &c — Vide Lit. Gaz. 25th July 1846 — photographed by Mr. H.
Fox Talbots kindness, from Mr. Jos. Bonomis design _____ London Augt. 46.
 George R. Gliddon

The date of this Tablet, according to Chevr. Bunsen, falls between
1397 and 1387 B.C.

(Left) *Antique statuette of a sphinx*, salt paper print from a calotype negative, ca. 1841
3¹⁵/₃₂ x 3²³/₃₂" (8.8 x 9.4 cm.)

(Below left) *Copy of printed page of Hebrew text*, photogenic drawing negative, ca. 1840
3⁵/₃₂ x 4" (8 x 10.2 cm.)

(Below) *Copy of a printed page of Hebrew text*, salt paper print from a photogenic drawing negative, ca. 1840
3¹⁵/₁₆ x 4¹¹/₃₂" (10 x 11 cm.)

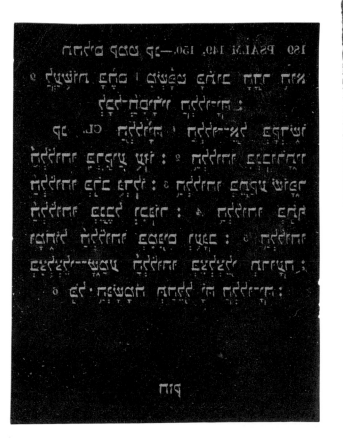

Hieroglyphic tablet, salt paper print
from a calotype negative, ca. 1841
8¹⁵/₁₆ x 7⁹/₃₂" (22.7 x 18.5 cm.)

ARCHITECTURE

I have not been able this summer to give more than a desultory and divided attention to the subject—I had and still have the intention of making a little photographic tour, in search of objects more picturesque than my own immediate neighbourhood supplies.
— W. H. F. Talbot, letter to Sir John Herschel, 1840

By 1840 the Industrial Revolution was rapidly changing both rural and urban life, as growing cities trading in new commodities began to attract country people looking for work. Talbot's studies of buildings during this period, however, reflect a relatively genteel and pastoral vision of England's architecture. Even as urban space was becoming increasingly congested, and dirty with the smoke of the new factory culture, Talbot chose to celebrate the older aspects of the city.

In the early 1840s Talbot made numerous photographic excursions throughout Britain and Europe. These trips, which in their itineraries were not unlike the grand tour he had taken in his youth, provided a wide range of subject matter and many opportunities to promote his new process. Given the technical limitations of early photography, movement could not be satisfactorily recorded. Talbot concentrated on buildings and monuments, preferring the intricate architectural features found on cathedrals and universities. Buildings figured in some of the earliest of Talbot's photographs, providing visually compelling and metaphorical spaces for reflecting on the new art. In 1839, he proclaimed Lacock Abbey the first building "that was ever yet known to have drawn its own picture,"[19] and the roofline of the nearby church of St. Cyriac was also the focus of early studies.

Talbot delighted in the play of light on the weathered surface of stone, and in the various textures that this produced. He traveled to Oxford in 1840 and 1843, taking the photograph that became the opening plate of *The Pencil of Nature*, depicting the neoclassical facade of Queen's College (p.53), during the later trip. Another view of this college, also included in *The Pencil of Nature*, shows the entrance gate. In the accompanying text, Talbot invites the reader to take up a "large lens . . . this magnifies the objects two or three times, and often discloses a multitude of minute details, which were previously unobserved and unsuspected."[20] He recognizes that the photograph contains an excess of information, but proposes a careful pouring over minutiae to discover details both mundane and profound: "Sometimes inscriptions and dates are found upon buildings, or printed placards most irrelevant, are discovered upon their walls: sometimes a distant dial-plate is

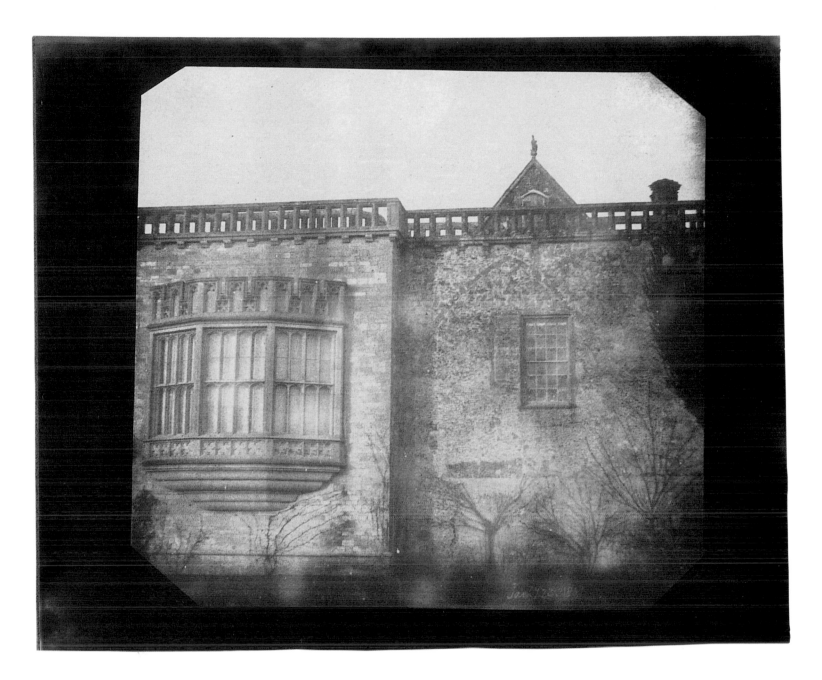

Exterior view of the Oriel window
at Lacock Abbey,
salt paper print from a photogenic
drawing negative, ca. 1840
$8^{31}/_{32}$ x $7^{9}/_{32}$" (22.8 x 18.5 cm.)

seen, and upon it—unconsciously recorded—the hour of day at which the view was taken."[21] This inevitably makes all readers undertake the role of detectives and introduces what Walter Benjamin would later describe as "unconscious optics."[22]

Talbot also writes of the silence and tranquility that seem to pervade the venerable abodes of learning in his photographs of Oxford. Even though traces of ghostly figures can be seen in certain pictures, the limitations of the camera equipment led to a denial of human presence—a place "abandoned by man, but spared by time."[23] Buildings were symbolic structures for Talbot; they embodied geometric principles and mathematical laws. Many of the photographs he took in Oxford in

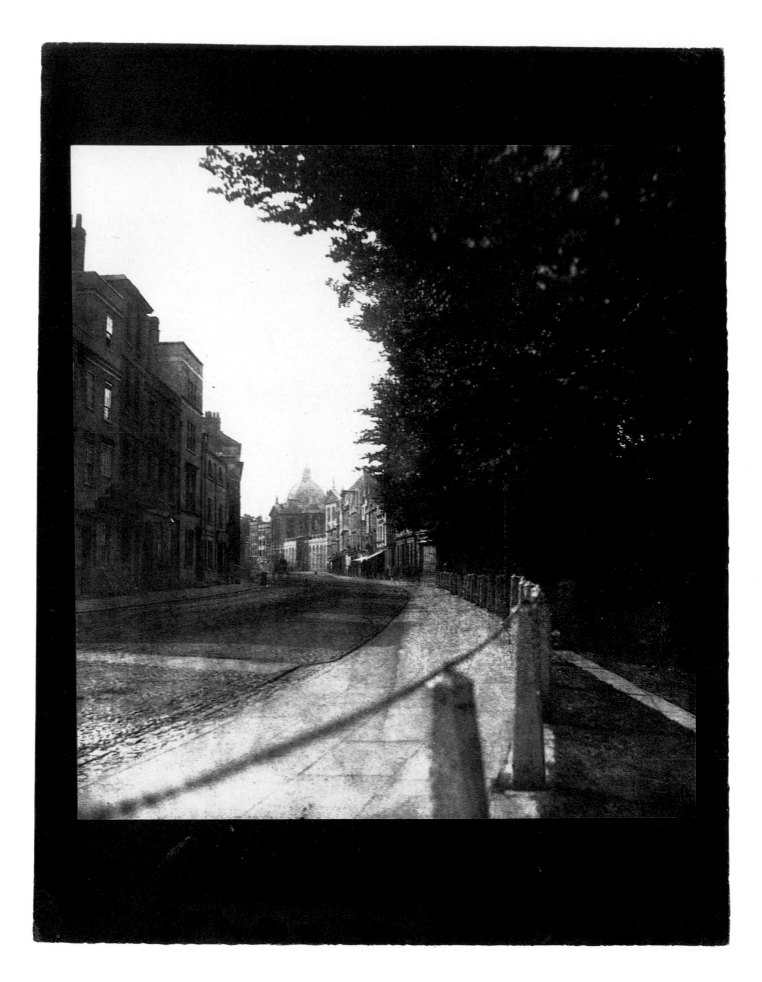

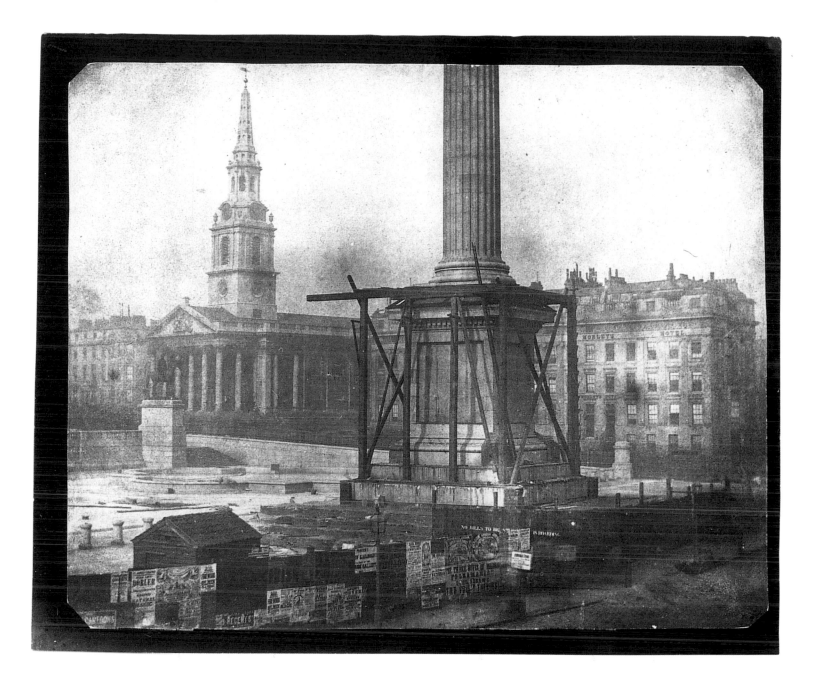

(Opposite) *High Street*, Oxford,
salt paper print from a calotype
negative, ca. 1842
7⁵/₈ x 9²⁷/₃₂" (19.4 x 25 cm.)

(Above) *Trafalgar Square*,
salt paper print, ca. 1845
8²⁷/₃₂ x 7³/₈" (22.5 x 18.7 cm.)

1843 demonstrate interests in the city's network of quadrangles, arches, and facades. With their doorways opening onto other doorways, these studies reveal a repetitive and serial emphasis that heightens the differences and similarities in the buildings photographed. The pictures are simultaneously topographical and typological. Talbot both isolated details of buildings and photographed them from a distance to show a building's scale in relation to those around it.

Talbot's early excursions with the camera presage a kind of travel that would grow exponentially with the modern tourist industry, which would draw extensively on photography.

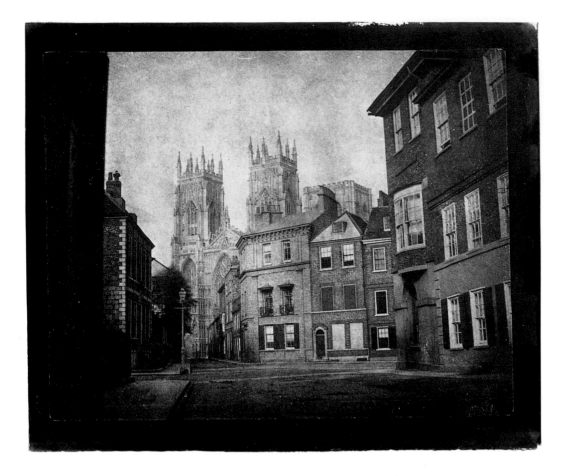

(Left) *York Minster*,
salt paper print from a calotype
negative, ca. 1845
$8^{13}/_{16}$ x $7^{5}/_{16}$" (22.4 x 18.6 cm.)

(Below) *Royal Exchange*, London,
salt paper print from a calotype
negative, ca. 1845
$8^{27}/_{32}$ x $7^{7}/_{16}$" (22.5 x 18.9 cm.)

(Opposite) *New Hall Library*,
London, salt paper print from a
calotype negative, ca. 1845
$7^{7}/_{8}$ x $9^{17}/_{32}$" (20 x 24.2 cm.)

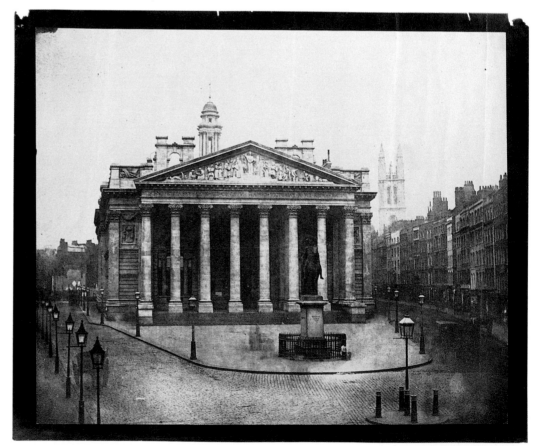

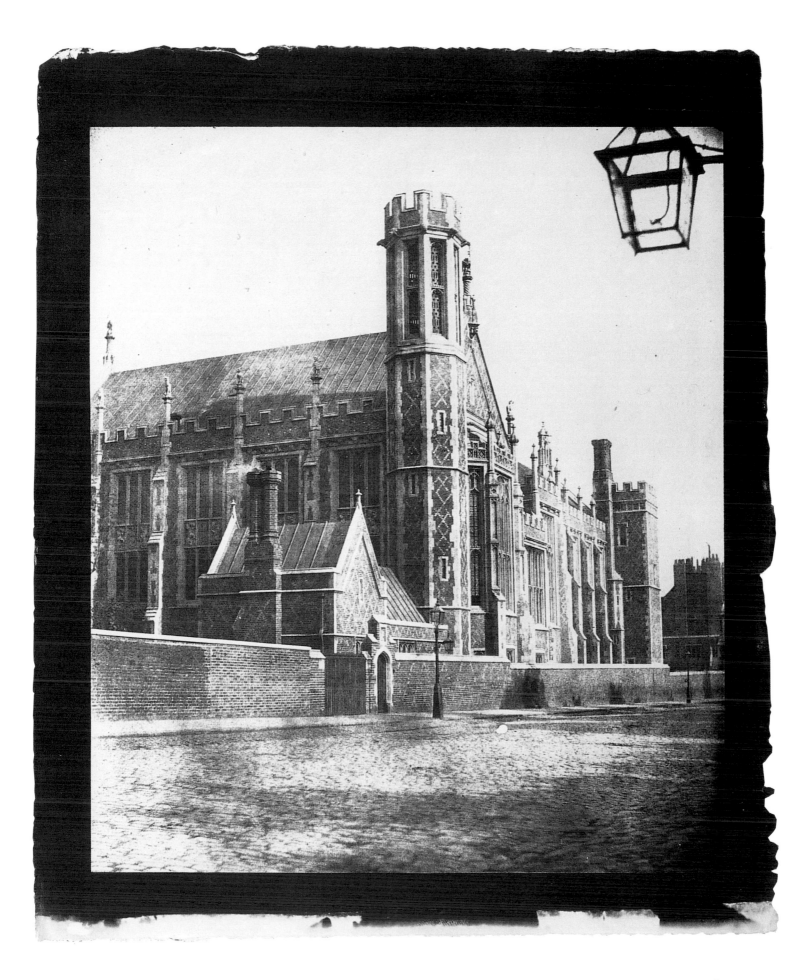

IN PRINTER'S INK
Photoglyphic Engraving

In 1855, the Photographic Society formed a study group, the Fading Committee, to explore the lack of permanence in paper-based photographic processes. The committee published its findings later that year. Talbot had felt these problems acutely since the production of *The Pencil of Nature*, and further misfortune was to plague his process when Nicolaas Henneman lost a valuable commission to illustrate the publication the *Exhibition of the Works of Industry of All Nations, 1851; Reports by the Juries*—a loss arising solely from the instability of prints made from calotype negatives.[13]

By the early 1850s, Talbot was already working on a method of reproducing photographs with greater permanence by using metal plates to photomechanically transfer prints to paper, using ink rather than silver as the basis of the image. In 1852, anticipating that the future of photography lay in its assimilation into the technology of the printing press, Talbot patented his first photomechanical process, which he called "photographic engraving." Building on the work of Gustav Suckow and Mungo Ponton in the 1830s, Talbot coated a steel plate with light-sensitive bichromated gelatin, which he then placed an object upon. Those areas unaffected by light were easily washed away to reveal an image in relief. In an account of this process published in *The Athenaeum* on April 9, 1853, Talbot's article described several attempts in Europe to engrave the daguerreotype image by chemical means. On seeing some examples by Hippolyte Louis Fizeau of Paris, he described the absence of "half-tints or gradations of shade—the want of which produces a harsh effect."[14] To counter this deficiency of tonal detail in his own process, Talbot proposed placing layers of gauze on a metal plate treated with a coating of potassium bichromate and gelatin. The result of exposing this plate to light "offers to the eye at a moderate distance the appearance of a uniform shading."[15]

Writing some three weeks later in the same journal, Talbot expanded on his proto-photomechanical process. Describing again how pieces of gauze or "photographic veils" were used, he explained that they were to form minute channels in the finished plate. An initial exposure was made with just the veil in contact with the plate; then a second exposure was made with the actual subject of the engraving in place—for example a leaf. The importance of the veil was that it created a network of fine lines on the plate, and these lines held ink, providing a semblance of tonality

(Opposite) *View of Edinburgh and fern,* photoglyphic engraving on paper, ca. 1853
$4^1/_4$ x $5^{31}/_{32}$" (10.8 x 15.2 cm.)

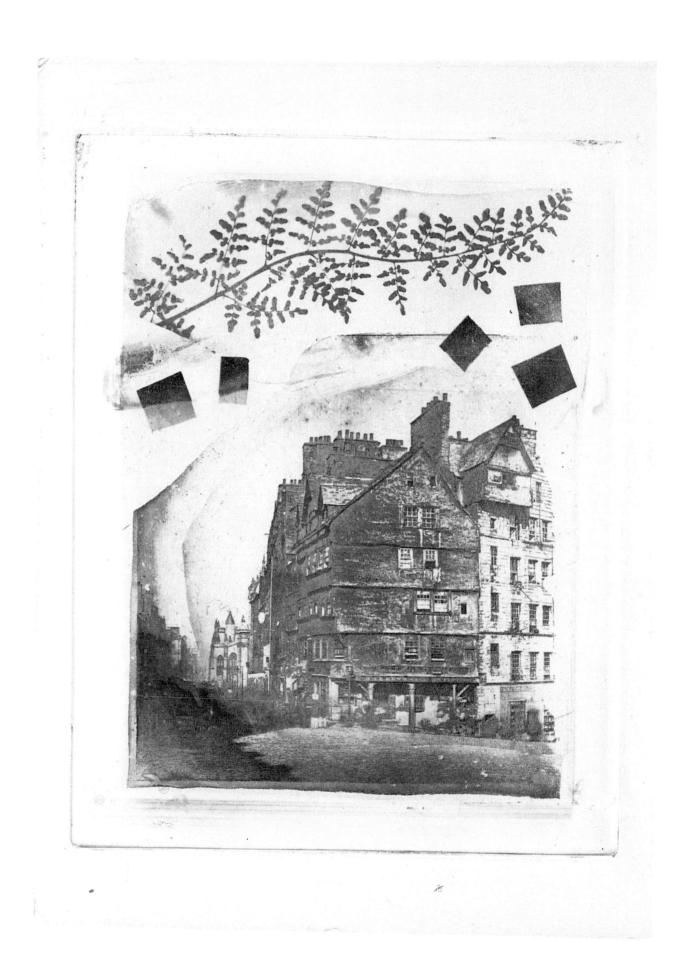

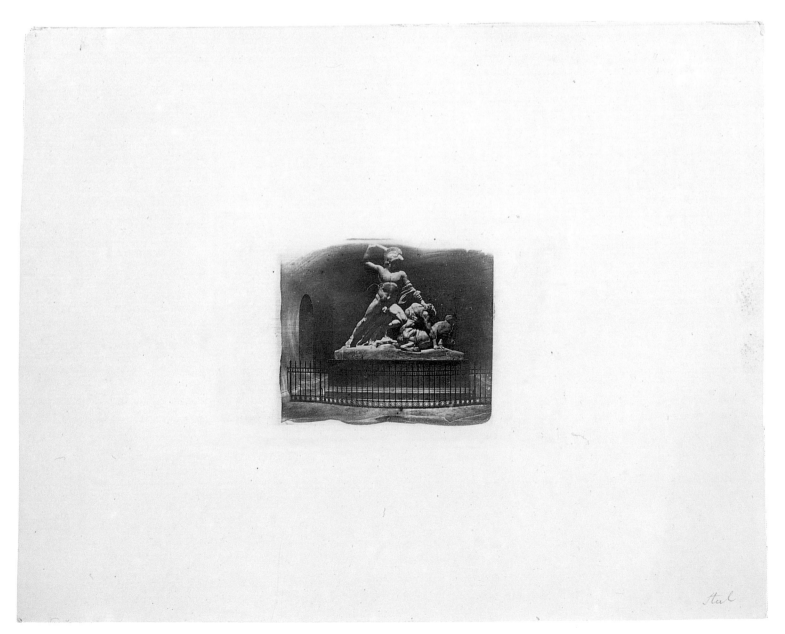

when printed. The print was eventually made after the plate was etched with nitric acid—the gelatin also acted as an acid resist—by inking up the relief and bringing the paper into contact with both raised and recessed parts of the plate that held ink.

This method provided the foundation for modern half-tone printing. It did so in two ways: first, in the use of gelatin to create the half-tone block, and second, in the application of a screen or veil to reproduce tonality. In 1858, Talbot patented this process as "photoglyphic engraving," but his innovations produced plates that were predominantly gravure. Talbot's discovery of bichromated gelatin as an appropriate surface for copying photographs became the backbone for many processes, including Karl Klîc's method of photogravure in 1879.

Photoglyphic engraving was the forerunner to modern gravure and half-tone processes. It is worth noting that Talbot returned to some of his earlier subject matter he had explored as part of his conventional photographic experiments—botanical specimens, sculpture, buildings. His engravings presented familiar subjects in different media. Talbot also copied the photographs of others.

Examples of photoglyphic engraving were included in *Photographic News* in November 1858. In 1877, Talbot began writing a supplement to the second addition of Gaston Tissandier's *History of Photography*; he was intending to discuss photomechanical printing, but died before completing the writing. Talbot's experiments with photomechanical reproduction provided the foundation for photogravure and half-tone processes that enabled photographs to be reproduced in books, newspapers, and advertisements—in short, the democracy of the image.

(Opposite top) *Statue of Hercules slaying a centaur*, copper plate, ca. 1853
5 x 3²⁵/₃₂" (12.7 x 9.6 cm.)

(Opposite below) *Statue of Hercules slaying a centaur*, photoglyphic engraving on paper, ca. 1853
7⁷/₈ x 9¹⁵/₁₆" (20 x 25.25 cm.)

(Right) *The Moon*, photoglyphic engraving on paper, ca. 1853
11²¹/₃₂ x 8¹⁹/₃₂" (29.6 x 21.8 cm.)

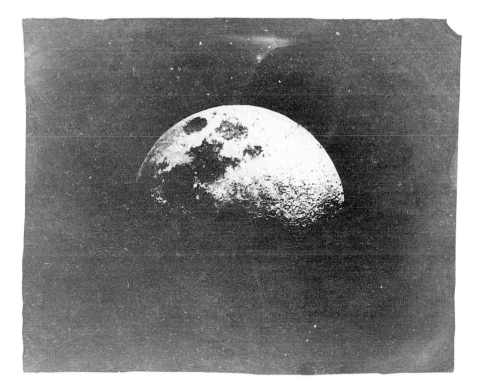

ADDITIONAL SELECTED IMAGES

The images in this book have been selected from the exhibition, *Specimens and Marvels: The Work of William Henry Fox Talbot*, organized by the National Museum of Photography, Film and Television, Bradford, to celebrate the two hundredth anniversary of Talbot's birth.

EXPERIMENTS

Head of Christ, salt paper print from a photogenic drawing negative, 1839
5³/₈ x 6¹/₃₂" (13.7 x 15.4 cm.)

THE ORDER OF NATURE

Photomicrograph of a botanical specimen
salt paper print, 1841
4¹/₂ x 3⁷/₁₆" (11.5 x 8.7 cm.)

Botanical specimen
photogenic drawing negative, ca. 1840
2⁹/₃₂ x 6¹/₄" (5.8 x 15.9 cm.)

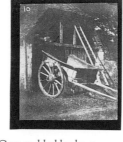

Honeysuckle
salt paper print, ca. 1842
8¹⁵/₁₆ x 7³/₈" (22.7 x 18.7 cm.)

Forbury Hill, Reading
salt paper print, ca. 1844
3³/₄ x 4¹⁷/₃₂" (9.5 x 11.5 cm.)

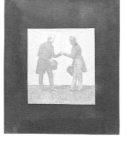

The Mirror
facsimile of a photogenic drawing by Talbot, 1839

PEOPLE, PLACES, AND THINGS

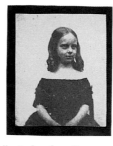

Lacock Abbey
salt paper print from a calotype negative, ca. 1842
8¹⁵/₁₆ x 7⁵/₁₆" (22.7 x 18.6 cm.)

Cart and laddar by a woodshed
salt paper print from a calotype negative, ca. 1843
4⁷/₁₆ x 7¹/₂" (11.3 x 19.1 cm.)

The Handshake
salt paper print, ca. 1842
7³/₈ x 8¹⁵/₁₆" (18.7 x 22.7 cm.)

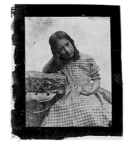

Talbot's daughter Rosamond
salt paper print from a calotype negative, ca. 1843
7³/₈ x 8¹⁵/₁₆" (9.1 x 11.3 cm.)

Talbot's daughter Ela
salt paper print from a calotype negative, ca. 1843
3³/₄ x 4⁹/₁₆" (9.5 x 11.6 cm.)

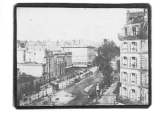

Rocking Horse at Lacock Abbey, Wiltshire
salt paper print from a calotype negative, ca. 1842
4²³/₃₂ x 3¹⁵/₁₆" (12 x 10 cm.)

FACSIMILES

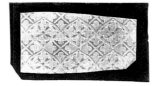

Cloth with chevron pattern
salt paper prints from photogenic drawing negative, ca. 1841
9¹/₁₆ x 7⁷/₁₆" (23 x 18.9 cm.)

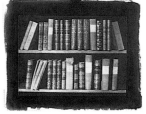

Patterned paper in the Gothic revival style
salt paper print using the original patterned paper as a negative, ca. 1840
4¹/₄ x 2³/₈" (10.8 x 6.1 cm.)

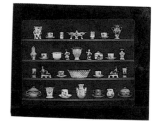

Copy of a handwriten manuscript of a poem with "Common Ink"
mixed media, salt paper print from photogenic drawing negative with ink inscriptions, ca.1842
3³/₈ x 2³/₈" (9.1 x 6 cm.)

THE PENCIL OF NATURE

View of the Boulevards at Paris, Plate II, *The Pencil of Nature*, salt paper print from calotype negatives, ca. 1843
8¹/₃₂ x 7¹/₈" (22.4 x 18.5 cm.)

Articles of China, Plate III, *The Pencil of Nature*
salt paper print from calotype negatives, ca. 1843
8¹/₃₂ x 7⁹/₃₂" (22.4 x 18.2 cm.)

Scene in a Library, Plate VIII, *The Pencil of Nature*
salt paper print from calotype negatives, ca. 1844
9¹/₁₆ x 7³/₈" (23 x 18.7 cm.)

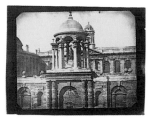

Queen's College, Oxford, Entrance Gateway, Plate XIII, *The Pencil of Nature*.
salt paper print from a calotype negative, 1843
9³/₄ x 7⁵/₈" (24.7 x 19.3 cm.)

Lovejoy's Library, Reading (Talbot/Henneman)
salt paper print from a calotype negative, ca. 1844
9¹/₈ x 7¹/₂" (23.2 x 19 cm)

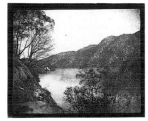

Loch Katrine
From *Sun Pictures in Scotland*
salt paper print from a calotype negative, 1845
8⁷/₈ x 7¹³/₃₂" (22.6 x 18.8 cm)

A mountain rivulet
From *Sun Pictures in Scotland*
salt paper print from a calotype negative, 1845
4¹/₄ x 3³/₈" (10.8 x 8.6 cm)

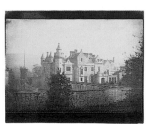

Abbotsford
From *Sun Pictures in Scotland*
salt paper print from a calotype negative, 1845
8¹³/₁₆ x 7⁹/₃₂" (22.4 x 18.5 cm.)

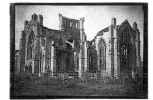

Melrose Abbey
From *Sun Pictures in Scotland*
salt paper print from a calotype negative, 1845
8³¹/₃₂ x 6¹/₄" (22.8 x 15.9 cm.)

THE ART OF REPRODUCTION

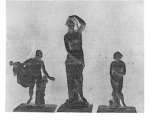

Three statuettes on brackets
calotype negative, ca. 1841
6¹/₂ x 5⁵/₁₆" (16.5 x 13.5 cm.)

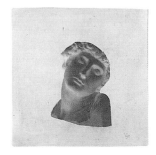

Detail of a classic statue
calotype negative, ca. 1841
5¹⁵/₁₆ x 5³¹/₃₂" (15.1 x 15.2 cm.)

ARTIFACTS

Study of an antique statue
salt paper print from a calotype negative, 1845
4¹/₁₆ x 5¹/₈" (11.9 x 13 cm.)

ARCHITECTURE

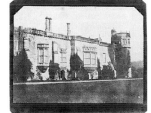

South Terrace, Lacock Abbey
salt paper print from a calotype negative, 1843
8²⁷/₃₂ x 7¹/₄" (22.5 x 18.4 cm.)

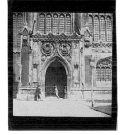

South door of Kings College Chapel, Cambridge
salt paper print from a calotype negative, 1843
7³/₈ x 9¹/₃₂" (18.7 x 22.9 cm.)

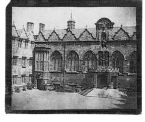

Oriel College, Oxford
salt paper print from a calotype negative, 1842
8¹³/₁₆ x 7¹¹/₃₂" (22.4 x 18.7 cm.)

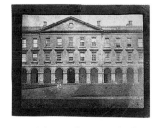

Magdalen College, Oxford
salt paper print from a calotype negative, 1842
4³/₈ x 3¹⁹/₃₂" (11.1 x 9.1 cm.)

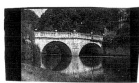

Clare College Bridge, Cambridge
salt paper print from a calotype negative, 1843
4⁷/₁₆ x 2¹³/₃₂" (11.2 x 6.1 cm.)

Cathedral, Orleans
salt paper print from a calotype negative, 1843
8⁷/₈ x 7⁹/₃₂" (22.5 x 18.5 cm.)

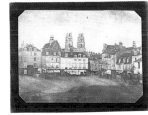

View of the Square, Orleans
salt paper print from a calotype negative, 1843
9⁷/₁₆ x 7¹/₂" (24 x 19.1 cm.)

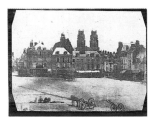

View of the Square, Orleans
salt paper print from a calotype negative, 1843
8⁷/₈ x 7" (22.5 x 17.8 cm.)

Boulevards, Hotel de la Paix, Paris
salt paper print from a calotype negative, 1843
3⁷/₈ x 7" (9.9 x 17.8 cm.)

IN PRINTER'S INK

Experimental photglyphic engraving, ca. 1853
8¹³/₁₆ x 5¹¹/₁₆" (22.3 x 14.4 cm.)

Seeds
copper plate, ca. 1853
6¹/₂ x 5⁵/₁₆" (16.5 x 13.5 cm.)

Experimental photglyphic engraving, ca. 1853
8¹³/₁₆ x 5¹¹/₁₆" (22.3 x 14.4 cm.)

WILLIAM HENRY FOX TALBOT, 1800–77
MIKE GRAY

William Henry Fox Talbot was born on February 11, 1800, at Melbury, Dorset, ancestral home of the Earls of Ilchester. At the time, his parents, William Davenport Talbot and Elisabeth Theresa Fox Talbot were staying with her father, Henry Thomas Fox Strangways the 2nd of Earl. His father, William Davenport Talbot, died on July 31 of the same year, when William Henry Fox Talbot, always called Henry, was only five months old, leaving behind a rundown estate and accumulated debts amounting to a sum of £30,000—an enormous liability, equivalent today to approximately $100,000,000. As a result, the Talbot family was unable to take full possession and ownership of Lacock Abbey until Henry Talbot reached his twenty-sixth year.

On April 24, 1804, Talbot's mother, Lady Elisabeth Horner Fox Strangways, married Captain Charles Feilding of the Royal Navy. In conjunction with the Ilchester family, Feilding would assist her in the task of reorganizing and running of the estate. Lady Elisabeth, according to Talbot's biographer H. J. P. Arnold, was "not only highly intelligent, but a seeker after knowledge, a natural linguist, a sparkling conversationalist, a Whig throughout her entire life . . . strong willed, obstinate—and spoilt from her first year on." Still, over the following ten years the family's affairs were placed on a more sound and substantial foundation, so that by 1810 virtually all outstanding and various accrued debts had been cleared. However, in order to generate and maintain an income for the education of the children, and to secure the family's future, it became necessary to rent out the whole of the Lacock Abbey estate.

When Henry came of age, on February 11, 1821, all "investments, consuls and annuities" passed directly to him. The Abbey and estate were by then in good repair, and all debts were paid, leaving a net annual income of around £1,800 (equivalent to about $500,000 today). The lack of a permanent home during Talbot's formative years does not seem to have had any adverse effect on him; on the contrary, he and his mother had a series of semipermanent homes where relationships were close and secure—with the Fox Strangways at Melbury; the Framptons at Morton Hall, Dorchester; the Lansdownes at Bowood, Wiltshire; but most of all at Penrice on the quiet and breathtakingly beautiful Gower peninsula, just a few miles from Swansea. Here Talbot came under the benign influence of a second formidable female, that of his aunt, Lady Mary Lucy,

wife of Thomas Mansel Talbot. Penrice occupied a special place in his childhood reminiscences and recollections, "providing happy memories he was never to forget and warm friendships with aunts and cousins which lasted throughout life." In addition, his innate love of learning and thirst for knowledge were nurtured not only by his mother but by his aunt, whose particular interest in botany first awakened his lifelong interest in the subject.

In 1808, Talbot was sent to Mr. William Hooker's preparatory school at Rottingdean, Sussex, England and three years later, in 1811, he entered Dr. Butler's house at Harrow. Judging by the reports of his teachers at the school, young Henry made exceptionally rapid progress—so much so that it was suggested that he should leave at the age of fifteen, since academically he had reached the top of the school but was not of sufficient maturity to be made head boy. At Harrow he also developed his interest in botany, and in conjunction with his young friend Walter Trevalyan prepared an index of local flora and fauna. After a short interval during which he had a series of private tutors, he went to Trinity College, Cambridge, under William Whewell, where he studied mathematics and the classics and was awarded the Porson Prize for Greek in 1820. Immediately after becoming the Chancellor's Medalist and obtaining First Class Honors in the Classics, he finally graduated in 1821.

Talbot took his obligations as the head of the family seriously, and after a visit to Lacock he decided to mark the occasion of his twenty-first birthday with a gift of £1,000 to fund the construction of a new school. The task was completed in 1824, and the school still functions to this day as the village school in Lacock.

In 1827, Talbot returned to Lacock and took up residence there. He was accompanied by his mother, Lady Elisabeth Feilding; his stepfather, now Rear Admiral Charles Feilding; and his two half-sisters, Caroline Augusta and Horatia Maria, as well as by their French governess, Amélina Petit de Billier. Between 1827 and 1831 the woodlands and gardens were replanned and replanted. Major structural changes were also made in the building, when three new oriel windows were added to a new, extended section of the South Gallery of the Abbey, one of these the small central latticed window that four years later Talbot made the subject of one of his earliest images.

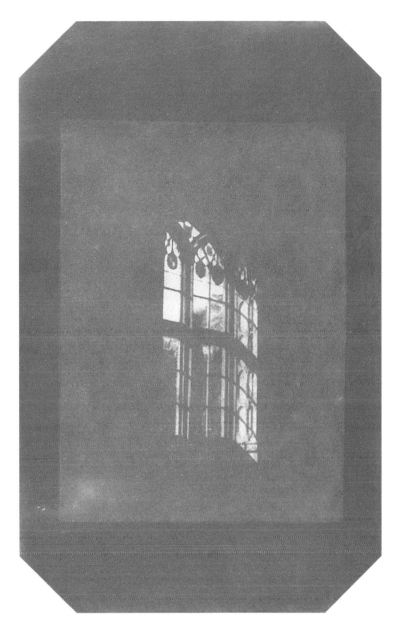

Sunlit window, Lacock Abbey, salt paper print from a photogenic drawing negative, ca. 1840 8⅞ x 7⁷/₃₂" (22.6 x 18.3 cm.)

on paper using the light-sensitive salts of silver. Talbot's studies of light in the mid 1820s marked the first phase of the optical researches that eventually led him toward the discovery, between August 1834 and September 1840, of the positive/negative photographic process.

Talbot's wife, Constance, whom he married in 1831, shared his interest in botany and was also an amateur watercolor painter. But his mother, Lady Elisabeth, and his half-sister Caroline were both more accomplished in this respect; they had received tuition from the drawing masters Varley, Bourne, Hancock, and Montgomerie. The latter, together with Hullmandel, introduced the two ladies to the new art of lithography, which had recently been established in Bath.

Between 1821 and 1834, Talbot and his family spent considerable periods of time on the Continent, visiting France, Switzerland, Italy, Austria, and the German states. Fluent in many languages and familiar with the arts and sciences of Europe, Talbot and his mother sought out and conversed with virtually all of the most prominent scientific and intellectual figures whose work and interests most closely mirrored his own. On most of these journeys Talbot included in his baggage a number of optical devices and drawing aids, among them various types of camera obscura, camera lucida, Claude glass, and occasionally a collimator, sextant, or theodolite.

One of these journeys was an extended honeymoon in northern Italy, in 1832, one year after his marriage to Constance. It was during this trip that Talbot experienced the first of the "philosophic visions" during which he speculated upon the possibility of images being able to form themselves spontaneously, "without the aid of an artist's pencil," and "by the agency of light alone." His point of inspiration has been elegantly and succinctly described by Neville Story Maskelyne, pioneer photographer and scientist, who noted that "it was on that beautiful Italian water whose triple arms converge on the point of Bellagio that Mr. Talbot longed for a power to enable him to bear away an image of the soft silvery radiance of Lecco and Como. There he resolved to work out the problem by which Nature herself would be induced to perpetuate the outline of her own beauties in artistic form." This somewhat romanticized but elegant account was drawn from Talbot's own introduction to his book *The Pencil of Nature*, where he described the reverie that marked the point where his ideas began to crystallize and coalesce.

Talbot commenced experimenting with salts of silver the following spring and early summer, first at Lacock, then, in early autumn, at Copet, near Geneva. No doubt his first ambition was to create a convenient way of recording botanical specimens. During the winter of 1835, he wrote up the findings of his experiments and set down the first description of

Between 1822, the year after Talbot's graduation, and 1872, the catalog of the Royal Society alone lists fifty papers by him within various domains of science. The first of these, "On the Properties of a Certain Curve drawn from the Equilateral Hyperbola," was followed by six further mathematical papers published in Gergonnes, Ann. Math., before the end of the following year. According to his first notebooks, Talbot seems to have begun his earliest researches into light in 1825, resulting in the publication of the papers "Some Experiments with Coloured Flames," 1826; "On Monochromatic Light," 1827; "On a Method of Obtaining Homogeneous Light of Great Intensity," 1834; and "On the Nature of Light," 1835. It was during this same period that he made his earliest experiments

the positive/negative process. Sometime after February 8, 1835, in Scientific Notebook M, he wrote: "In the Photogenic or Sciagraphic process [*skia* meaning "shadow" in Greek], if the paper is transparent, the first drawing may serve as an object, to produce a second drawing, in which the lights and shadows would be reversed."

"The brilliant summer of 1835," as Talbot described it, saw significant advances. He was making several kinds of photogenic drawing. The first involved the superimposition of objects on treated papers, which were fixed after exposure with sodium chloride, potassium iodide, or potassium bromide. The resulting prints were lilac, burnt orange, or other similar shades, according to the chemicals employed to stabilize the proofs. In August 1835, Talbot made between three and four small paper negatives of the small oriel window in the South Gallery of Lacock Abbey. This group of images included the annotated specimen now held in the archives of the National Museum of Photography, Film and Television in Bradford, England.

Between 1835 and 1838, Talbot virtually ceased his photographic studies and experiments. On January 7, 1839, however, François Arago, secretary of the French Chamber of Deputies and a well-known scientist (when Talbot had worked at the Paris Observatory, in 1825 and 1829, Arago had been its director), announced Louis Jacques Mandé Daguerre's invention of the daguerreotype, without giving specific details, as reported in *Compte Rendu*, a journal giving detailed accounts of all important scientific meetings and events in France. The announcement appears in translation in London's *Literary Gazette* on January 19. Talbot was surprised and shocked; he immediately dispatched samples of his work to be displayed at the meeting of the Royal Institution on Friday January 25, and wrote his now famous paper, "Some Account of the Art of Photogenic Drawing or the Process by which Natural Objects May be Made to Delineate Themselves without the Aid of the Artist's Pencil." The paper was submitted to the Royal Society on January 31. Talbot also sent letters to Arago, Jean Baptiste Biot, and Alexander von Humboldt, the scientists who had verified Daguerre's invention, informing them that he intended submitting a formal claim of prior invention to the Acadèmie. He also dispatched correspondence to all his close scientific associates in England and Europe.

Between January 1839 and October 1840, Talbot worked intensively to speed up his basic process. His experiments resulted in his final discovery: the development of the latent negative photographic image, the calotype negative/positive process, realized in principle and in practice on September 23, 1840. Images could now be produced in seconds rather than minutes. All modern photography originates from this unique discovery. Talbot's genius lay in his ability to bring together the results of his own discoveries with the work of a number of the earlier proto-photographic pioneers. Between 1844 and 1847, he marked out photography's future by setting up the world's first photographic printing and developing facility, in Reading, halfway between Lacock and London. Between 1844 and 1847, this workshop—the Establishment, managed by Talbot's former assistant and valet, Nicolaas Henneman—produced something on the order of fifty thousand prints. Notable among them were those made to illustrate Talbot's *The Pencil of Nature*, the first photographically illustrated book, published in six parts between 1844 and 1846.

From the extensive notes Talbot made at the time, we can see that by 1843 he had already observed, noted, and used many of the techniques now part of contemporary photographic studio and darkroom practice: reciprocity failure; shadow and highlight masking; pin registration; the use of reflectors and black flags; and, remarkably, pseudo-solarization. Moreover, around 1842 he proposed the use of the telephoto lens, electronic flash, infrared photography, and phototypesetting, while at the same time his later discoveries laid down the groundwork of photogravure printing technology. Reference is still made today to the Talbot-Klîc process. In his lifetime Talbot also made important and significant contributions in many other fields, including philology, botany, physics, optics, chemistry, crystallography, spectroscopy, and the translation of Egyptian and Assyrian cuneiform scripts.

By the time Talbot died on September 17, 1877, his positive/negative process had become universally adopted throughout the world. (Yet his contribution is still to be fully appreciated and acknowledged in the United States.) According to an anonymous obituary published in *Nature* on October 18, 1877, "Orientalists will call to mind that Talbot was one of the first who, with Sir Henry Rawlinson and Dr. Hincks deciphered the cuneiform inscriptions bought from Nineveh. He was the author of several books of much interest and learning, and in his *Pencil of Nature*, a fine quarto published in 1844, and probably the first work illustrated by photographs, he describes the origin and progress of the conception which culminated in his invention"—photography.

NOTES

1. See Hannah Arendt, ed., *Illuminations* (London: Fontana, 1973), pp. 219–253. The original version of Benjamin's essay was published in Zeitschrift für Sozialforschung, V. no 1, New York, 1936. Valéry's "La Conquête de l'ubiquité" was originally published in *De la musique avant chose*, Editions du Tambourinaire, Paris, 1927. Arendt's reference is taken from Ralph Manheim's translation in *Aesthetics* (New York: Pantheon Books, 1964), p. 225.

2. W. H. F. Talbot, *Some Account of the Art of Photogenic Drawing or the Process by which Natural Objects may be made to Delineate Themselves without the Aid of the Artist's Pencil* (London: R. & J. E. Taylor), 1839.

3. Three invaluable publications for assessing the intellectual frameworks and motivations for Talbot's work are: Gail Buckland, *Fox Talbot and the Invention of Photography* (London: Scolar Press, 1970); Larry Schaaf, *Out of the Shadows* (New Haven and London: Yale, 1992); Geoffrey Batchen, *Burning with Desire* (Cambridge and London: MIT, 1997).

4. *Printed Light* was a collaboration between John Ward (Science Museum) and Sara Stevenson (Scottish National Portrait Gallery), the latter explored the work of Hill and Adamson parallel with Ward's account of Talbot. See *Printed Light—The Scientific Art of William Henry Fox Talbot and David Octavius Hill with Robert Adamson* (Edinburgh: HMSO, 1976).

5. W. H. F. Talbot, "Brief Historical Sketch of the Invention of the Art," *The Pencil of Nature* (London: Longman, Brown, Green & Longmans, June 1844) Part I.

6. Ibid

7. Ibid

8. W. H. F. Talbot, *Some Account of the Art of Photogenic Drawing or the Process by which Natural Objects may be made to Delineate Themselves without the Aid of the Artist's Pencil* (London: R. & J. E. Taylor, 1839).

9. See Thomas Wedgwood and Sir Humphry Davy, "An Account of a Method of Copying Paintings upon Glass, and of Making Profiles, by the Agency of Light Upon Nitrate of Silver," *Journals of the Royal Institution of Great Britain*, vol. 1, 1802, pp.170–74

10. "Magic pictures," "natures marvels," and "words of light" are phrases from Talbot's Notebook P, in the NMPFT Collection: Notebook P, March/April, 35, 1839. Sir David Brewster used the words "black art" in reference to photography in a letter to Talbot dated February 12, 1839, see *Selected Correspondence of William Henry Fox Talbot 1823–1874*, ed. L. Schaaf (London: Science Museum/NMPFT, 1994), p17. Talbot uses "fairy pictures" to describe the ephemeral quality of the landscape as seen through the camera obscura, and to set the stage for his method of fixing these magical images, see his "Brief Historical Sketch of the Invention of the Art" in *The Pencil of Nature*, Part 1, June 1844.

11. W. H. F. Talbot, *Some Account of the Art of Photogenic Drawing or the Process by which Natural Objects may be made to Delineate Themselves without the Aid of the Artist's Pencil* (London: R. & J. E. Taylor, 1839).

12. From a letter dated September 7, 1840 (LA 40-32), National Trust Fox Talbot Museum, Lacock.

13. See Nancy Keeler, "Illustrating the 'Reports by the Juries' of the Great Exhibition of 1851; Talbot, Henneman, and Their Failed Commission, History of Photography," Vol. 6, No. 3, July 1972, pp.257–272.

14. W. H. F. Talbot, "Photographic Engraving," *The Athenaeum*, No. 1327, April 9, 1853, p.450.

15. W. H. F. Talbot, "Photographic Engraving," *The Athenaeum*, No. 1331, April 30, 1853, p.533.

16. W. H. F. Talbot, "Leaf of a Plant," *The Pencil of Nature*, Part 2, January 29, 1845.

17. W. H. F Talbot, Notebook P, September 23, 1839.

18. "The New Art," *Literary Gazette*, February 2, 1839, p.72–75.

19. W. H. F. Talbot, *Some Account of the Art of Photogenic Drawing or the Process by which Natural Objects may be made to Delineate Themselves without the Aid of the Artist's Pencil* (London: R. & J. E. Taylor, 1839).

20. W. H. F. Talbot, "Queen's College, Oxford. Entrance Gateway," *The Pencil of Nature*, Part 3, May 1845.

21. Ibid

22. Walter Benjamin, "The Work of Art in the Age of Mechanical Reproduction," reproduced in Hannah Arendt, ed., *Illuminations* (London: Fontana, 1973), p.239. Benjamin writes "Here the camera intervenes with the resources of its lowering and liftings, its interruptions and isolations, its extensions and accelerations, its enlargements and reductions. The camera introduces us to unconscious optics as does psychoanalysis to unconscious impulses."

23. W. H. F. Talbot, Plate XVII "Gate of Christchurch," *The Pencil of Nature*, Part 4, June 1845.

24. Susan Stewart, *On Longing—Narratives of the Miniature, the Gigantic, the Souvenir, the Collection* (Durham and London: Duke University Press, 1993), p137.

25. W. H. F. Talbot, Plate XXIII "Hagar in the Desert," *The Pencil of Nature*, Part 6, April 1846.

26. W. H. F. Talbot, Plate V "The Bust of Patroclus," *The Pencil of Nature*, Part 1, June 1844.

27. André Malraux, "Museum without walls," *The Voices of Silence*, translated by Stuart Gilbert, Bollingen Series (New Jersey: Princeton University Press, 1977), p.16.

SELECTED BIBLIOGRAPHY

Arnold, H. J. P. *W. H. Fox Talbot*, London: Hutchinson Benham, 1977.

Ballerini, J. "Recasting Ancestry: Statuettes as Imaged by Three Inventors of Photography," in Lowenthal, A. ed. *The Object as Subject: Essays on the Interpretation of Still Life*. Princeton: Princeton University Press, 1996.

Batchen, G. *Burning with Desire: The Conception of Photography*. Cambridge & London: MIT Press, 1997.

Brettel, R., Flukinger, R., Keeler, N., and Kilgore, S.M. *Paper and Light: The Calotype in France and Great Britain*. Massachusetts: David R. Godine, 1984.

Buckland, G. *Fox Talbot and the Invention of Photography*. Boston: David Godine, 1980.

Flukinger, R. L. *Photographs of the Great Exhibition of 1851*. Austin: University of Texas Press, 1977.

Jammes, A. and Janis, E. P. *The Art of French Calotype*. Princeton: Princeton University Press, 1983.

Lassam, R. E. *Fox Talbot Photographer*. Tisbury: Compton Press, 1979.

Lassam, R. E., Morris, R. and Seabourne, M. *The Calotype Process*. Lacock: The Fox Talbot Museum, 1979.

Nickel, D. "Nature's Supernaturalism: William Henry Fox Talbot and Botanical Illustration," in Howe, K.S. ed. *Intersections: Lithography, Photography, and the Traditions of Printmaking*. Albuquerque: University of New Mexico Press, 1998.

Schaaf, L.J. "Introductory Volume," W. H. F. Talbot's *The Pencil of Nature: Anniversary Facsimile*. New York: Hans P. Kraus, Jr. Inc., 1989

Schaaf, L. J. *Out of the Shadows: Herschel, Talbot and the Invention of Photography*. New Haven: Yale University Press, 1992.

Schaaf, L. J. *The Photographic Art of William Henry Fox Talbot*. New Jersey: Princeton University Press, 2000.

Smith, G. "Talbot and Botany: The Bertoloni Album," History of Photography, Vol. 17, no. 1, Spring 1993.

Solomon-Godeau, A. "Calotypomania: The Gourmet Guide to Nineteenth-Century Photography," *Photography at the Dock-Essays on Photographic History, Institutions, and Practices*. Minneapolis: University of Minnesota Press, 1991.

Talbot, W. H. F. *The Pencil of Nature*. Longman, Brown, Green & Longmans, London, Part 1, June 1844. Reprinted as a facsimile edition with an introduction by Beaumont Newhall. New York: Da Capo Press, 1969.

Talbot, W. H. F. *Some Account of the Art of Photogenic Drawing or the Process by which Natural Objects may be made to Delineate Themselves without the Aid of the Artist's Pencil*. London: R. & J. E. Taylor, 1839. Reprinted in Newhall, B., Photography: Essays & Images. New York: Museum of Modern Art, 1981.

Ward, J. "The Fox Talbot Collection at the Science Museum," History of Photography, Vol. 1, no. 4, October 1977.

Ward, J. and Stevenson, S. *Printed Light: The Scientific Art of W. Fox Talbot and D.O. Hill with R. Adamson*. Edinburgh: HMSO, 1986.

Weaver, M. "Henry Fox Talbot: Conversation Pieces," *British Photography in the Nineteenth Century*. M. Weaver, ed. Cambridge and New York: Cambridge University Press, 1989.

Weaver, M. ed. *Henry Fox Talbot—Selected Texts and Bibliography*, Oxford: Clio Press, 1992.

Aperture gratefully acknowledges Amanda Nevill, Head of Museum; Russell Roberts, Curator of Photographs;
and Greg Hobson, Head of Programme, of the National Museum of Photography, Film and Television, Bradford,
for their support and essential contributions and for making available
the invaluable collection of William Henry Fox Talbot's work for this publication.

Michael Gray, Director of the National Trust Fox Talbot Museum, Lacock,
kindly provided meaningful text on William Henry Fox Talbot for the edition
of the publication produced for general distribution.

Library of Congress Catalog Card Number: 00-107102
Hardcover ISBN: 0-89381-917-4
Separations by Articrom, Velate, Italy
Printed and bound by Mariogros Industrie Grafiche SpA, Turin, Italy

The Staff at Aperture for
Specimens and Marvels: William Henry Fox Talbot and the Invention of Photography:
Michael E. Hoffman, Executive Director
Michael L. Sand, Executive Editor
Hiuwai Chu, Associate Editor
Stevan A. Baron, V.P., Production
Lisa A. Farmer, Production Director
Wendy Byrne, Designer
Bryonie Wise, Editorial Work-Scholar
Noah Bowers, Design Work-Scholar

Aperture Foundation publishes a periodical, books, and portfolios of fine photography and presents world-class exhibitions to communicate with serious photographers and creative people everywhere. A complete catalog is available upon request.
Aperture Customer Service: 20 East 23rd Street, New York, New York 10010. Phone: (212) 598-4205. Fax: (212) 598-4015. Toll-free: (800) 929-2323. E-mail: customerservice@aperture.org
Aperture Foundation, including Book Center and Burden Gallery: 20 East 23rd Street, New York, New York 10010. Phone: (212) 505-5555, ext. 300. Fax: (212) 979-7759. E-mail: info@aperture.org

Visit Aperture's website: www.aperture.org

Aperture Foundation books are distributed internationally through:
CANADA: General/Irwin Publishing Co., Ltd., 325 Humber College Blvd., Etobicoke, Ontario, M9W 7C3. Fax: (416) 213-1917.
UNITED KINGDOM, SCANDINAVIA, AND CONTINENTAL EUROPE: Robert Hale, Ltd., Clerkenwell House, 45-47 Clerkenwell Green, London, United Kingdom, EC1R OHT. Fax: (44) 171-490-4958.
NETHERLANDS, Belgium, Luxemburg: Nilsson & Lamm, BV, Pampuslaan 212-214, P.O. Box 195, 1382 JS Weesp, Netherlands. Fax: (31) 29-441-5054.
AUSTRALIA: Tower Books Pty. Ltd., Unit 9/19 Rodborough Road, Frenchs Forest, Sydney, New South Wales, Australia. Fax: (61) 2-9975-5599.
New Zealand: Southern Publishers Group, 22 Burleigh Street, Grafton, Auckland, New Zealand. Fax: (64) 9-309-6170.
INDIA: TBI Publishers, 46, Housing Project, South Extension Part-I, New Delhi 110049, India. Fax: (91) 11-461-0576.

For international magazine subscription orders to the periodical *Aperture*, contact Aperture International Subscription Service, P.O. Box 14, Harold Hill, Romford, RM3 8EQ, United Kingdom. One year: $50.00. Price subject to change. Fax: (44) 1-708-372-046.

To subscribe to the periodical *Aperture* in the U.S.A. write Aperture, P.O. Box 3000, Denville, New Jersey 07834. Toll-free: (800) 783-4903. One year: $40.00. Two years: $66.00.

Further information about the National Museum of Photography, Film & Television's collections and research facilities can be obtained from the Curator (Collections Access) at the National Museum of Photography, Film & Television, Bradford, BD1 1NQ, U.K. Tel: (44) 1274-202050. Fax: (44) 1274-723155. E-mail: enquiries@nmpft.ac.uk Reproduction rights can be obtained from the Science and Society Picture Library, Science Museum, London SW7 2DD, U.K. Tel: (44) 207-942-4400. Fax: (44) 942-4401. E-mail: piclib@nmsi@ac.uk.

First Edition
10 9 8 7 6 5 4 3 2 1